The Campus History Series

VIRGINIA MILITARY INSTITUTE

ON THE COVER: E Company is pictured in formation in front of Barracks in 1925. The Barracks and Jackson Arch can be seen in the cover's background. Only a couple of years before this 1930 aerial image was made, the fourth side of Barracks was completed, thus enclosing the courtyard for the first time. (Both images courtesy of the VMI Archives.)

The Campus History Series

VIRGINIA MILITARY INSTITUTE

KEITH E. GIBSON

ARCADIA
PUBLISHING

Copyright © 2010 by Keith E. Gibson
ISBN 978-0-7385-8646-5

Published by Arcadia Publishing
Charleston, South Carolina

Printed in the United States of America

Library of Congress Catalog Card Number: 2010925345

For all general information, please contact Arcadia Publishing:
Telephone 843-853-2070
Fax 843-853-0044
E-mail sales@arcadiapublishing.com
For customer service and orders:
Toll-Free 1-888-313-2665

Visit us on the Internet at www.arcadiapublishing.com

To Pat,
with whom I share my passion for the past
and with whose advice and patience
this volume is a much better work

CONTENTS

ACKNOWLEDGMENTS

From official images to candid cadet shots, the rich history of the Virginia Military Institute is documented in thousands of photographs. I am indebted to Col. Diane Jacob, head archivist, and Mary Laura Kludy, archives assistant, of the VMI Archives for making the collection available and professionally tolerating my many visits and requests.

I also wish to thank Col. Stewart MacInnis, director of VMI Communications and Marketing; Burton Floyd, media specialist; Wade Branner, associate athletic director; Barbara Blakey, registrar, VMI Museum; Susan Cain, reader; Adam Volant, executive vice president, VMI Alumni Association; and especially Kathryn Wise, senior editor, Alumni Review. These are all colleagues with whom I am grateful to be associated.

Unless otherwise noted, all images appear courtesy of the VMI Archives. Additional images appear courtesy of: the VMI Museum (VMIM); the VMI Alumni Association (VMIAA); the office of VMI Communications and Marketing (C&M); the office of VMI Sports Information (SID); and the U.S. Department of Defense (DoD).

INTRODUCTION

The War of 1812 revealed that the young nation was not well prepared to defend its shores. Virginia sought to strengthen its defense with the construction of two arsenals in which to store military equipment that would be needed by the state militia in times of emergency. One of these arsenals was built west of the Blue Ridge Mountains in Lexington, Virginia.

Established in 1816, the brick buildings of the Lexington Arsenal were located on a ridge overlooking the North (Maury) River on the outskirts of the county seat. By 1830, the newspapers carried increasingly frequent notices of desertions and carousal by the loosely organized young militiamen. On one occasion, a fight between two of the arsenal guards resulted in death. The state facility was becoming an undesirable element in the quiet community of Scots-Irish Presbyterians.

Convinced that the Commonwealth of Virginia could better the civilian career prospects of the 20 young militia men guarding the state arsenal, local lawyer John T. L. Preston proposed that the soldiers be provided an education during their tour of duty. Virginia led the nation by being the first state to include a military college as part of its public education system. Graduates were expected to repay the state by becoming public school teachers or state engineers. Any young Virginia man interested in paying his way through the Institute could attend without a postgraduate requirement of service to the commonwealth. Preston's concept became reality on November 11, 1839, when the first 25 cadets relieved the militia arsenal guard.

The initial faculty consisted of Francis H. Smith and John T. L. Preston. An 1833 graduate of West Point, Smith served as principal professor and superintendent. Preston, an alumnus of Washington College (now Washington and Lee University), taught modern languages and the classics.

By the late 1840s, it was clear that the aging arsenal buildings were not adequate for the plans Superintendent Smith had for his college. Noted New York architect Alexander Jackson Davis was commissioned to create new barracks, a mess hall, and several faculty houses. The cadets moved into their new Gothic-Revival four-story Barracks in the fall of 1851. In addition to providing housing for the Cadet Corps, the Barracks included classrooms, library, laboratories, and bachelor faculty housing.

One of the faculty members who moved into the new facilities in 1851 was Maj. Thomas Jonathan Jackson, who had arrived to assume his duties as professor of natural philosophy and artillery tactics. Ten years later on April 21, 1861, he was ordered to take the Cadet Corps to Richmond to act as drill instructors for the fledgling Confederate Army. During the summer of 1861, the cadets trained over 15,000 recruits. By the end of that summer, Major Jackson would be known around the world as "Stonewall" Jackson.

During the Civil War, over 1,800 of the 2,000 eligible alumni served in the Confederate army, and only 16 served in the Union forces. The Cadet Corps was called out 15 times during the war in response to Union threats in the Shenandoah Valley. At the Battle of New Market on May 15, 1864, the 257-member Cadet Corps found itself in the center of the Confederate infantry attack. The commanding general credited the resulting victory to the courage of the young cadets. Victory came at the price of 10 cadet lives. Six of the ten who died are buried on the grounds of VMI today.

On June 12, 1864, a Union force of 18,000 strong, under the command of Gen. David Hunter, advanced upon Lexington. Hunter ordered the Barracks burned. Superintendent Smith was compelled to find temporary quarters for his school in Richmond until the end of the war.

Convincing the faculty to work for a fraction of their pre-war salary, Smith began the rebuilding of VMI in the fall of 1865. By the academic year of 1867, the Barracks had been restored. Among the distinguished faculty who helped rebuild the college was Matthew Fontaine Maury, who had gained international fame charting the ocean's currents.

By the early 1900s, the Corps had grown to 700 strong. The Institute embarked upon an aggressive building plan as it prepared for the new century. Bertram Goodhue was commissioned to create a new architectural master plan. With a strong commitment to A. J. Davis's Gothic-Revival style, Goodhue expanded the Barracks, enlarged the Parade Ground, and designed the impressive Jackson Memorial Hall.

Anticipating service in Europe during World War I, cadets dug elaborate trench systems into what later became the football field. More than 1,400 alumni served in the armed forces during the war.

World War II brought an accelerated academic program to accommodate early graduation. VMI was selected by the federal government as one of the U.S. Army Specialized Training Program (ASTP) sites around the nation. More than 4,000 alumni answered the call to arms between 1941 and 1945.

After the war, many former cadets, now armed with the G.I. Bill, returned to complete their education. The Barracks was again enlarged. The expanded corps size benefited the academic and athletic programs. Under the leadership of coach John McKenna, the "Keydets" achieved their first undefeated season in 1957 and appeared on the first foldout cover of Sports Illustrated.

The Corps increased in size and diversity throughout the 20th century. African Americans first graduated as members of the Class of 1971. Women arrived at VMI in 1997, and today they comprise roughly eight percent of the 1,500 member Cadet Corps.

Over the past 170 years, from its founding on November 11, 1839 through the 20th century—and now into the 21st century—VMI has prepared citizen-soldiers for leadership roles in civilian and military pursuits. The photographs that follow chronicle J. T. L. Preston's experiment in higher education—the Virginia Military Institute.

One

THE NATION'S FIRST
STATE MILITARY COLLEGE

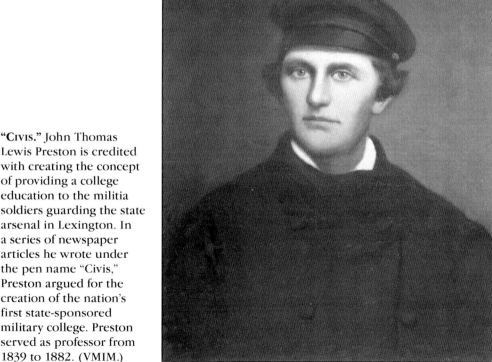

"Civis." John Thomas Lewis Preston is credited with creating the concept of providing a college education to the militia soldiers guarding the state arsenal in Lexington. In a series of newspaper articles he wrote under the pen name "Civis," Preston argued for the creation of the nation's first state-sponsored military college. Preston served as professor from 1839 to 1882. (VMIM.)

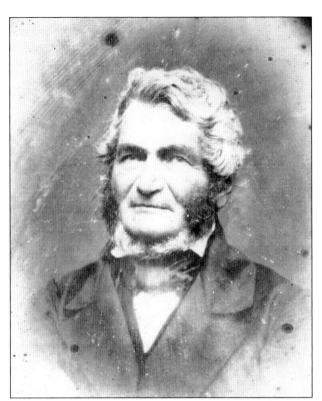

FIRST PRESIDENT OF THE BOARD OF VISITORS. Claudius Crozet (1789–1864) was the first president of the VMI Board of Visitors, the governing body of the college. He came to the United States from France in 1816, after serving as an artillery officer under Napoleon. Educated at Ecole Polytechnique, Crozet taught math at West Point before coming to Virginia as the engineer of public works. He is credited with introducing the chalkboard to the American classroom. He is buried at VMI near the building, which bears his name.

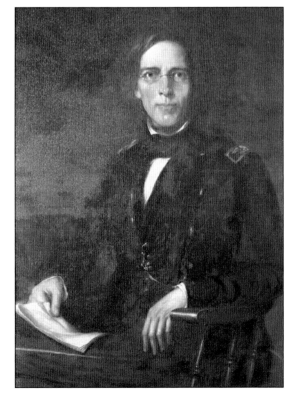

FRANCIS HENNEY SMITH (1812–1890). Smith was a professor of mathematics at Hamden-Sydney College in 1839 when he was offered the position of the founding superintendent of Virginia's new military college. Smith, an 1824 graduate of West Point, proved to be the ideal candidate for the challenge. His vision and leadership guided the young college through its first 50 years.

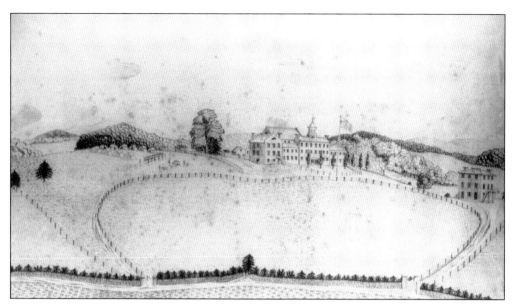

A Cadet's View Of VMI, 1842. Cadet Charles Deyerle (1842), a member of the first graduating class, created this pencil drawing of the Institute—the earliest known view of the newly founded college. The Barracks (with cupola) is flanked by faculty quarters. The 1816 arsenal roof can be seen to the rear. On the right is the first mess hall, which was built in 1840. To the left, Deyerle depicted a cadet encampment.

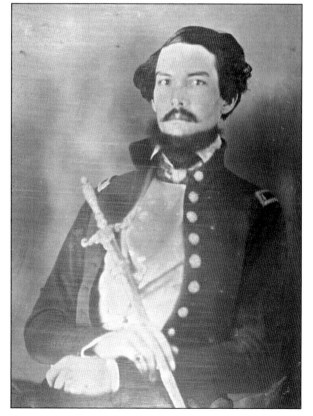

The First Career Officer to Die on Active Duty. Charles Deyerle (1842) received his medical degree from Jefferson Medical School in 1846. He accepted a commission as surgeon in the army at the outbreak of the war with Mexico, and was assigned to the 2nd Artillery, 1st Division under General North at Vera Cruz. He was with General Scott's army at the capture of Mexico City. Major Deyerle was sent to California in 1849, first to Benicia Barracks and later to Fort Humboldt on the northern coast. Shortly after returning to Benicia Barracks, Deyerle died in October 1853. While at Benicia Barracks, he sent flower seeds to his sister in Salem, Virginia. Years later, the Deyerle family presented these seeds and other items to the VMI Museum.

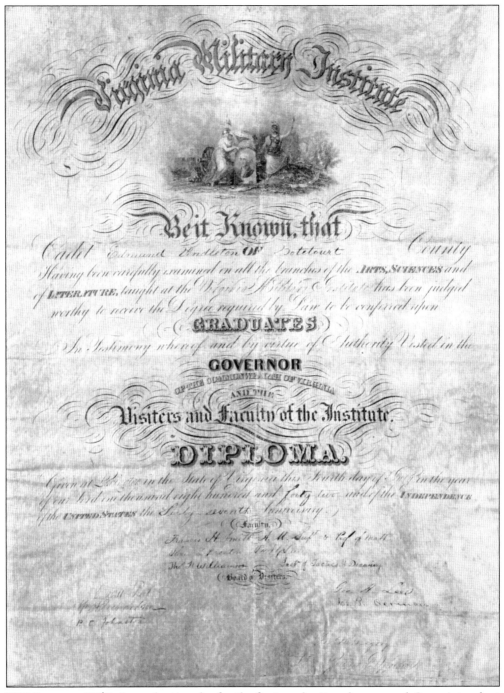

VMI Diploma, 1842. As graduation day for the first graduating class neared, Superintendent Smith ordered 100 diplomas made by noted engraver James Smellie of New York. The first order of diplomas lasted for six years. The current document is virtually identical to the very first one presented on July 4, 1842. At 14-by-18 inches, it is one of the largest undergraduate diplomas in the nation and is believed to be the only one signed by a governor. This diploma was awarded to Edmond Pendleton, who became a lawyer and Virginia state legislator.

VMI Cadet, 1845. This cadet, believed to be Daniel Langhorne (1845), is one of the earliest known images of a VMI cadet in uniform. He is wearing a model 1839 forage hat and a single-breasted blue surtout coat, which was authorized for wear only by first classmen (seniors). Langhorne came to VMI from nearby Lynchburg, Virginia. He graduated 7th in a class of 20, became a physician, and served as lieutenant colonel of the 42nd Virginia Infantry during the Civil War.

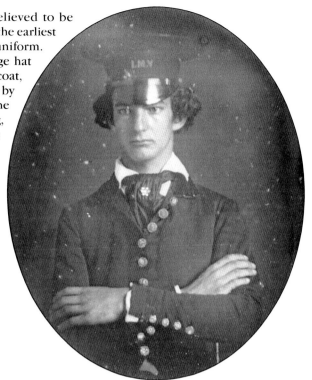

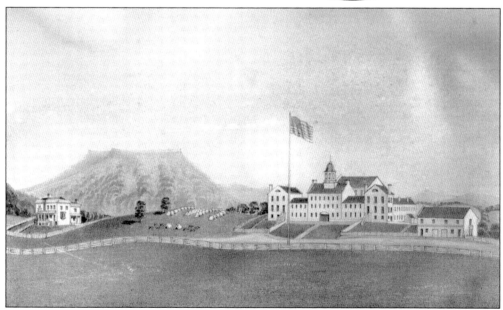

VMI, 1847. This is the earliest known official view of VMI. From left to right are the superintendent's quarters (1847) with House Mountain in the background; the Guard Tree and cadet encampment; the Cadet Barracks with cupola (1816 with 1840 story added) flanked by faculty quarters; the roof of the Arsenal, seen behind the barracks; and the gun shed with library above (1844). Farther to the right, but not seen in this view, was the 1840 kitchen with recitation rooms above.

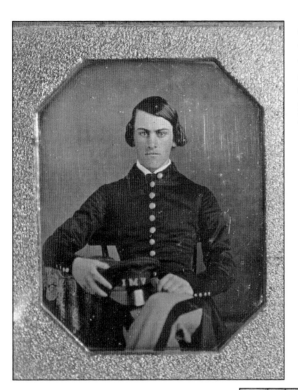

CADET CHARLES RICE (1850). Shown wearing his first classman's uniform, Charles Rice graduated fifth in his class of 17 students. His career as a civil engineer was tragically cut short in 1859, when he contracted Yellow Fever and died.

MARCH 2, 1855. This 1855 sketch provides insight into a typical cadet barracks room. The unknown cadet artist titled it "March 2nd 1855. Friday night. 15 minutes to Tattoo." Note the mattresses (called "hays" in VMI parlance) rolled and stacked in the corner of the room. Cadets are still required to roll their "hays" and stack their "hayracks" (cots) before breakfast every morning.

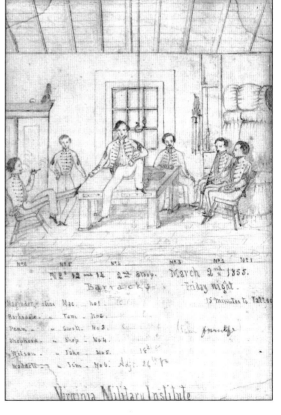

MAJ. THOMAS J. "STONEWALL" JACKSON. Major Jackson arrived at VMI in the fall of 1851 to assume the professorship of natural philosophy and artillery tactics. An 1846 graduate of West Point, he was not well prepared to teach the demanding course. In contrast, the artillery officer excelled in his duties as instructor of artillery. He was given his nickname "Stonewall" at the Battle of Manassas in July 1861. Jackson intended to return to his duties at VMI after the Civil War, but he was accidentally mortally wounded by his own men in May 1863. (VMIM.)

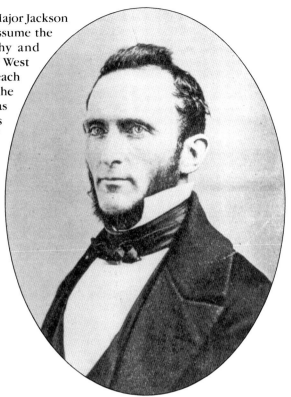

REPORT CARD, 1857. Cadet Abram Fulkerson's 1857 marks were good enough to place him 12th in his class of 22. Fulkerson's practical jokes won him fame among his fellow cadets. Once he wore an outlandish collar (the only uniform item not detailed by cadet regulations) to Maj. Thomas Jackson's class. During the Civil War, Fulkerson became colonel of the 63rd Tennessee. He was twice wounded and twice captured. Following the war, he became a lawyer and politician. Fulkerson was elected to terms in the Virginia Senate and the U.S. House of Representatives.

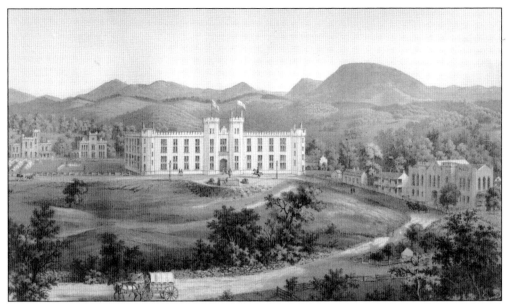

THE INSTITUTE, 1857. When noted artist Casimir Bohn visited Lexington in 1857, the implementation of Alexander Davis's architectural plan was well underway. The accurate and detailed print provides an excellent view of the facilities of the young college. The structures are, from left to right, as follows: Samuel Moore house (razed around 1950); Porter's Lodge (razed 1915); superintendent's quarters and VMI Headquarters; faculty residence (Gilham); faculty residence (Williamson); Barracks; laundry; hospital; and mess hall.

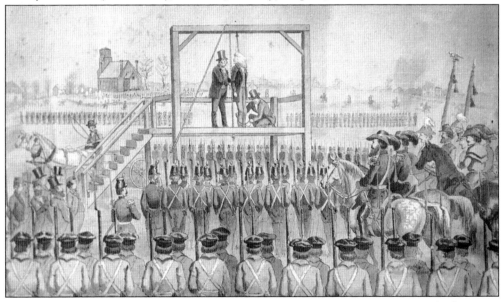

CADETS ATTENDING JOHN BROWN'S EXECUTION. When John Brown was convicted of treason in 1859 for his raid on Harpers Ferry and was sentenced to hang, every available military unit in Virginia was called to Charles Town, including the VMI Cadet Corps. On the day of the execution, December 2, 1859, the Cadet Corps (seen in the foreground of the sketch), formed up near the gallows. The officer in charge of the execution was VMI superintendent Francis Smith. VMI professor Maj. Thomas Jackson was also present.

ON THE EVE OF WAR. Cadet Scott Shipp (standing on right) was photographed with fellow members of the Class of 1859 wearing their "coatees," (dress uniform jackets). Shipp matriculated at VMI from Missouri, one of the first non-Virginia cadets to attend after the 1858 ruling that cadetship was no longer restricted to Virginians. After graduation, he became the commandant of cadets and commanded the Corps at the Battle of New Market until he was wounded. Returning to the Institute after the Civil War, Shipp became the second superintendent of VMI in 1889.

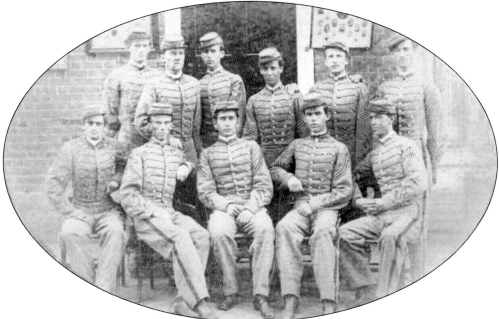

THE BATTLE OF NEW MARKET. These 11 members of the Class of 1867 all fought in the Battle of New Market on May 15, 1864. The 257-member Cadet Corps was thrust into the center of an infantry charge against a larger Union force. Many cadets lost their shoes charging across a rain-soaked wheat field into the enemy line. Ten cadets died as a result of the battle. The event marks the only time in American history that a college student body victoriously fought in pitched combat.

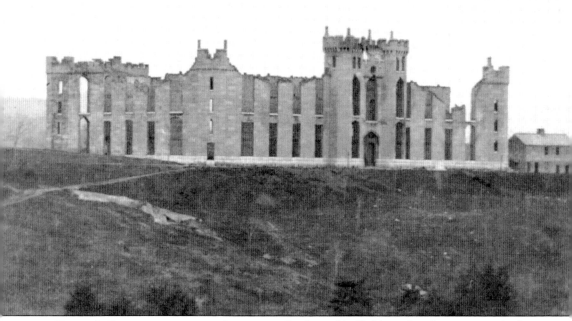

Hunter's Destruction of the Institute. On June 11, 1864, under the command of Maj. Gen. David Hunter, 18,000 Union forces arrived in Lexington. Perhaps in retaliation for the pivotal role played by the cadets one month earlier at the Battle of New Market, Hunter ordered the burning of the Institute. Following the destruction, a temporary home for VMI was established at the Alms House in Richmond.

Two

THE REBUILDING

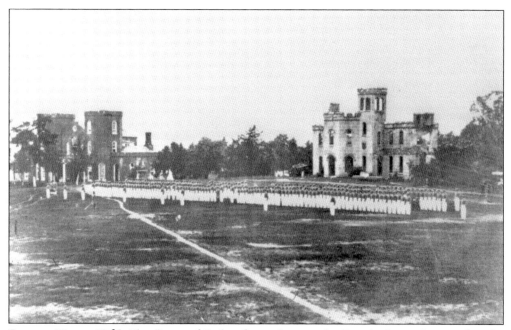

BACK TO WORK, 1865. The Corps of Cadets formed up on the Parade Ground soon after the post–Civil War reopening of VMI. Destruction from Hunter's Raid is clearly visible, including the ruins of the faculty residence of Maj. William Gilham. He was the author of the drill manual used by many Confederate units during the war. By 1868, the house was rebuilt and assigned to newly arrived professor Matthew Fontaine Maury.

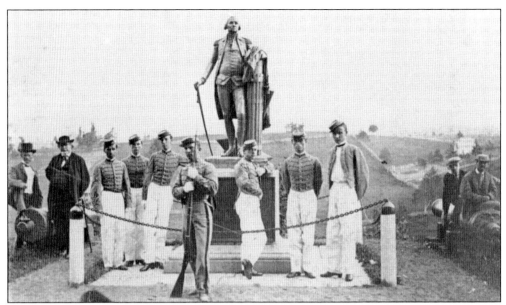

THE RETURN OF WASHINGTON! This bronze copy of Houdon's famous likeness of George Washington, which has stood watch over the Barracks since 1856, was taken by Union soldiers as a war trophy in 1864. They intended to take the statue to West Point, New York, but the heavy prize did not make it further than West Virginia. Following the war, arrangements were made to return Washington to his base outside the VMI Barracks. This image was taken after the September 1866 rededication ceremony.

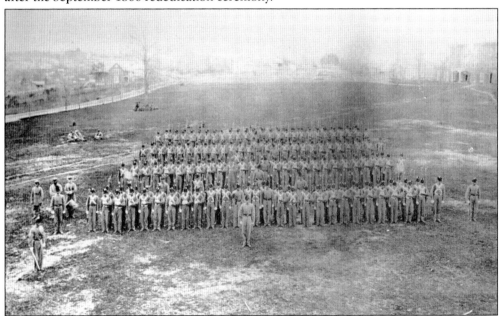

CORPS FORMATION, 1869. Positioned in a second story window of the VMI Barracks, a photographer captured the formation of the four-company VMI Cadet Corps in 1869. The occasion of the image could have been to show off the recently arrived Austrian muskets—the first time that the Corps was allowed to carry arms since the end of the Civil War. Several alumni pooled their funds to purchase these inferior rifles to reequip the Corps.

FUNERAL OF ROBERT E. LEE. "[The Corps] formed around the college chapel and he was buried in the chapel. . . . The procession was a very large one, a great many persons from a distance being here," wrote cadet William Nalle 1872. He was one of the cadets chosen to stand guard over Lee's casket in the chapel. The former Confederate general died on October 12, 1870, after serving as president of Washington College for five years. Shortly after Lee's death, the college officially changed its name to Washington and Lee University.

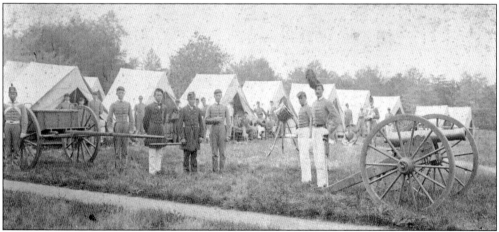

SUMMER CAMP SCENE. During the 19th century, the months of July and August were spent in a military encampment on the Parade Ground. Practical military instruction took the place of academic pursuits. Cadet William Nalle (1872) is pictured right front as officer of the guard. He served as colonel of the 3rd Virginia Infantry during the Spanish-American War (1896–1898) and later served for eight years as the Adjutant General of Virginia.

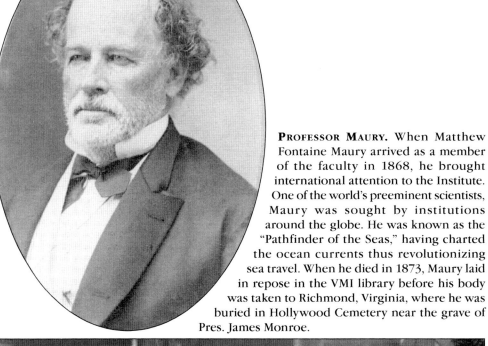

PROFESSOR MAURY. When Matthew Fontaine Maury arrived as a member of the faculty in 1868, he brought international attention to the Institute. One of the world's preeminent scientists, Maury was sought by institutions around the globe. He was known as the "Pathfinder of the Seas," having charted the ocean currents thus revolutionizing sea travel. When he died in 1873, Maury laid in repose in the VMI library before his body was taken to Richmond, Virginia, where he was buried in Hollywood Cemetery near the grave of Pres. James Monroe.

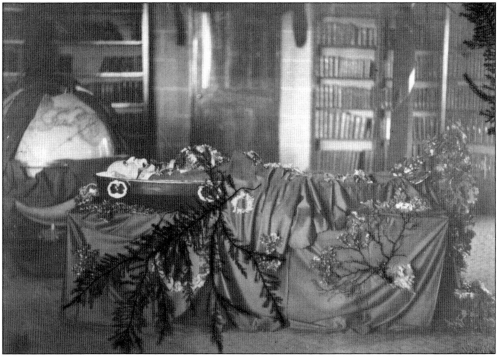

CADET GROUP, AROUND 1885. This group of four unidentified cadets and a U.S. Army corporal gathered for a studio photograph in the mid-1880s. The cadets are in full dress, coatees (dress coat) with cross belts, waist belts, and shakos (dress hat). The corporal may be a relative of one of the cadets, or perhaps he is a former classmate.

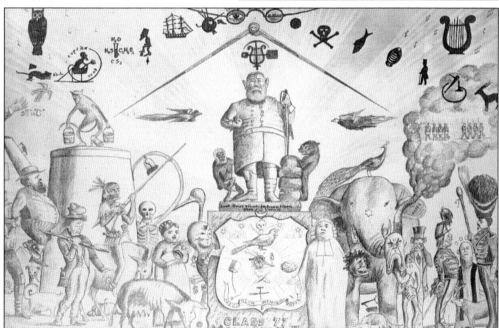

CADET HIEROGLYPHICS. Cadet humor for the Class of 1877 took the form of this cartoon of VMI life, complete with caricatures of faculty and cryptic symbols of secret societies. The image of the statue in the center of the drawing carries the caption "Look, There stands Jackson like a mud wall," an irreverent reference to pre–Civil War VMI professor "Stonewall" Jackson. Members of this class included George S. Patton (father of the World War II general) and Robert Marr, longtime VMI professor of engineering and drawing.

23

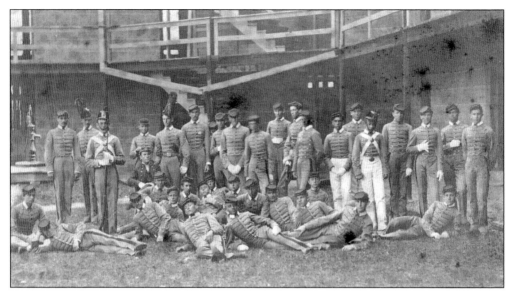

Barracks Group, around 1880. A group of cadets gathered in the northeast corner of Barracks about 1880. Several classes and a number of uniform variations are present—from the Guard Team officer of the day (standing, center with plumed hat) to a Guard Team sentinel (cadet with rifle). The water pump and cistern (to the left) were installed during the post–Civil War rebuilding of the Barracks to provide a water source in the event of fire. The long-abandoned cistern was rediscovered in the mid-1990s, when the tire of a tractor working in the courtyard crashed through the top of the cistern.

Baseball, 1884. Athletics has always been a part of life at VMI. This image of the "Base Ball Nine, 1884–1885" appeared in the 1885 cadet yearbook. Robert Withers (1885) played right field on the team. He became senior vice president of the Aluminum Company of America (Alcoa) and served as vice-council to China. The first recorded game of baseball at VMI took place in the fall of 1866. The opponents were from nearby Washington College (now Washington and Lee University).

24

FOOTBALL TEAM, 1885. The early days of football were not constrained by many rules, and the game little resembled the one we know today. It was a blend of rugby and soccer. The ball was the size of a basketball. The number of players was limited only by the available candidates, and the size of the field was agreed upon by the teams playing. The first official football coach did not arrive at VMI until 10 years after this image was made.

ALUMNI GATHERING, 1889. In 1889, VMI celebrated the semicentennial of the founding of the college. Proud alumni gathered on the Parade Ground in front of the Commandant's House to commemorate the first 50 years of the Institute. The VMI Alumni Association was established in 1842, at the time of the graduation of the first class.

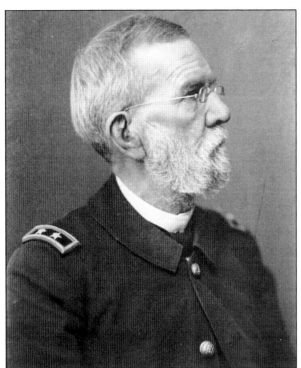

BUILDER AND REBUILDER. By 1889, Francis H. Smith was known as the "Builder and Re-builder" of VMI. He retired after 50 years of service, very shortly after this image was made. He died just a few months later.

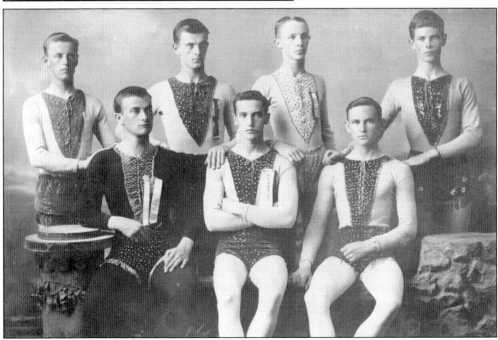

GYMNASTICS TEAM, 1889. Since the time of the Greeks, tumbling and gymnastics have been a manner in which soldiers demonstrate agility and strength. In the late 1880s, splashy stage costuming was apparently important as well. Seated in the center of this group is Samuel Rockenbach (1889). Rockenbach became a brigadier general in the U.S. Army, and he is considered the "Father of the U.S. Army Tank Corps," as he pioneered the use of armored vehicles.

SCOTT SHIPP 1859, SUPERINTENDENT: 1890–1907. Brig. Gen. Scott Shipp was the second superintendent and the first VMI graduate to hold the post. Following his graduation in 1859, Shipp joined the VMI faculty as professor of Latin and mathematics. He became commandant of cadets in 1862 and commanded the cadets in 1864 at the Battle of New Market, where he was seriously wounded. Shipp served on the Board of Visitors of the Naval Academy as well as West Point. Scott Shipp Hall, the liberal arts building, is named in his honor.

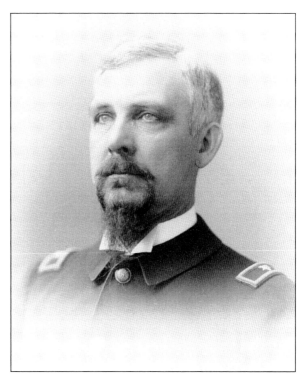

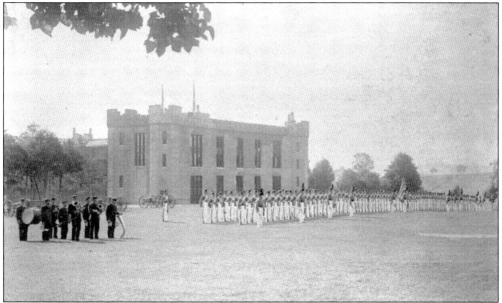

PARADE, 1890. Formal parades have always been an integral part of cadet life. The basic format of the parade has remained the same but the frequency has reduced from daily in the early 19th century to once a week in the 21st century. The VMI Band (on the left in this 1890 image) was made up of employees who, in addition to other duties such as working in the mess hall, provided musical accompaniment during parades. The war-scarred Barracks (note the discoloration near the top of the wall) can be seen in the background. The left end of the building is where Jackson Arch is located today.

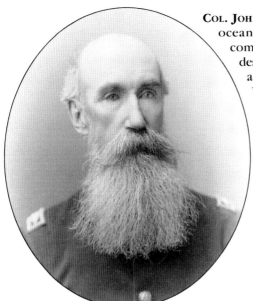

COL. JOHN MERCER BROOKE. A well-known as an U.S. oceanographer, Brooke resigned his U.S. Navy commission at the start of the Civil War. He designed the celebrated Brooke Naval Gun as well as the armor plating of the Confederate ironclad *Virginia*. The duel between the CSS *Virginia* and the USS *Monitor* ended the era of wooden ships. In the 1850s, Brooke served as navigator on the ship that brought the first Japanese government officials to the United States. He taught at VMI from 1865 until his death in 1906. His great grandson and a great-great grandson, both VMI alumni, currently serve on the VMI faculty.

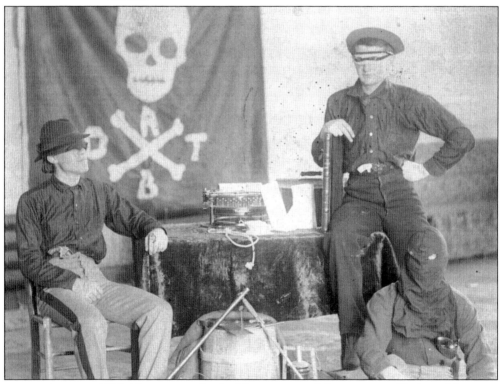

MOLLY MAGUIRES, 1890. The nature of cadet life encouraged the creation of fashionable secret societies such as the Molly Maguires. Unlike their namesake, the cadet group did not engage in radical social reform but rather limited their activities to setting off small black powder bombs in the Barracks courtyard for excitement. By the early 1900s, these organizations fell out of favor with the Corps, although the cry "Bomb in the Courtyard!" continued to be heard from time to time in the Barracks until well after World War II.

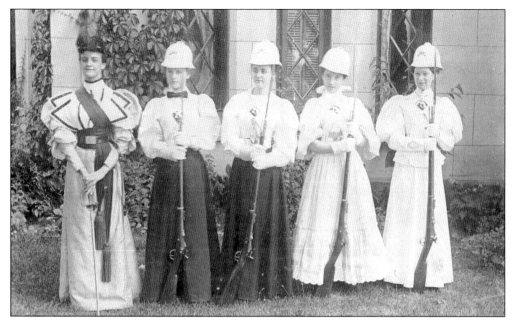

THE FIRST FEMALE CADETS? Decades ahead of their time, these young ladies donned cadet helmets, rifles, sashes, and swords in a parody of the VMI Guard Team in 1890. Women did not officially enter VMI until 100 years after this image was taken. The ladies are posed in front of the Maury House.

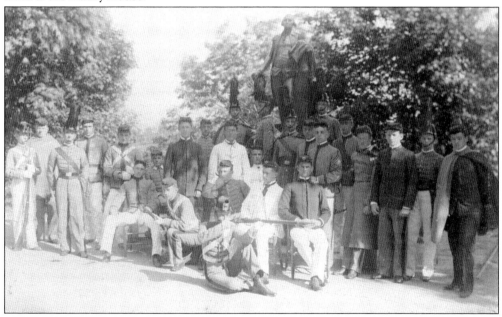

A UNIFORM FOR EVERY OCCASION. Members of the Class of 1892 posed next to Washington's statue to display the array of uniforms worn in the late 19th century. Several of the uniforms are still in use—the full dress coatee, the gray blouse, and the overcoat. Others such as the cape and the blue blouse (first cadet on the right) and the white summer uniform (second cadet from right, seated) are no longer in use. The cadet kneeling in the front is aiming a U.S. Springfield Cadet Model Trapdoor rifle.

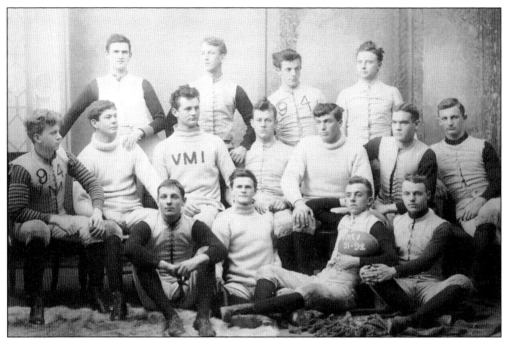

FIRST INTERCOLLEGIATE FOOTBALL TEAM, 1891. The first college football game played in the South was between VMI and Washington and Lee University on October 21, 1891. VMI won the contest 6–0.

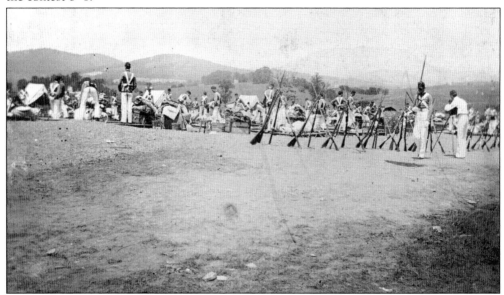

SUMMER CAMP, 1891. In the early years, summer camp was held on the Parade Ground and lasted from graduation (usually July 4) until the start of the new school year (usually September 1). By 1890, the camp lasted from the end of exams until graduation—a period of about two weeks. In this image, the cadets have just come from formation and are enthusiastically engaged in pitching their tents. The cadet walking guard (far right) does not seem as enthusiastic. The cadets are wearing the newly issued gray blouse uniform, which served as the class uniform until the 1930s and is still worn.

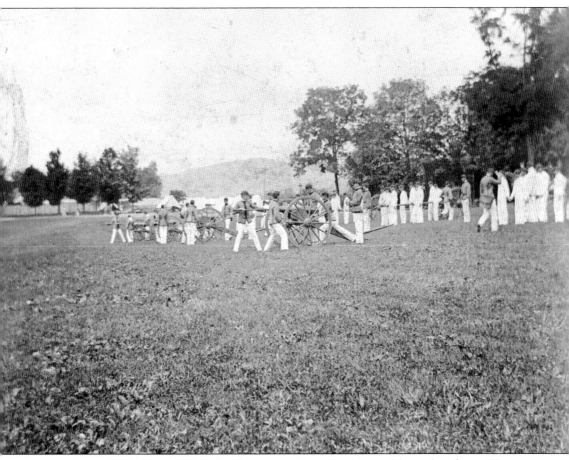

BATTERY DRILL, 1892. The 1848 Cadet Battery continued to be used by cadets for artillery training until the late 19th century, when the muzzle-loading cannon became obsolete. The Cadet Battery was designed especially for VMI and arrived in 1848. The battery, consisting of four 6-pound cannon and two 12-pound howitzers—each weighing about 300 pounds less than full-sized guns, was intended only for drill. Each bronze tube is marked with the seal of the Commonwealth of Virginia. When Maj. Thomas Jackson arrived in 1851 as professor of artillery tactics, he took command of the battery. Since no horses were available, cadets filled the role of draft animals as well as the firing crew. In 1861, the guns went to war with the Rockbridge Artillery. One of the 12-pounders was lost before the battery was returned to VMI.

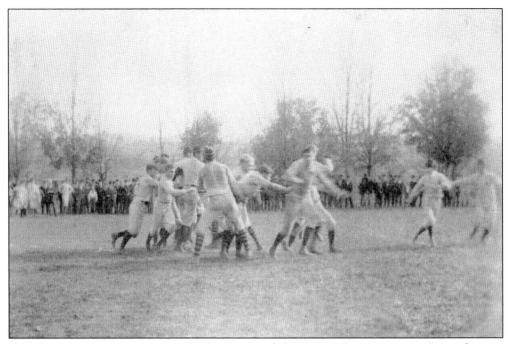

FOOTBALL ON THE PARADE GROUND. This is one of the earliest known action shots of a VMI football game, taken in 1893. Football was played on the Parade Ground until 1921, when it moved to its present location in Foster Stadium.

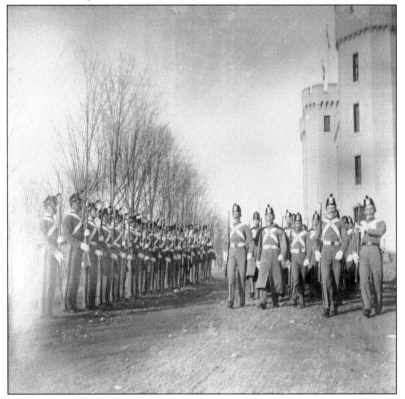

THE CHANGING OF THE GUARD. Since November 11, 1839, when the first cadet sentinel took his post, the cadet guard team has stood 24-hour guard over the Institute while the school is in session. Here the team being relieved (left) salutes the oncoming guard team (right) as it marches by.

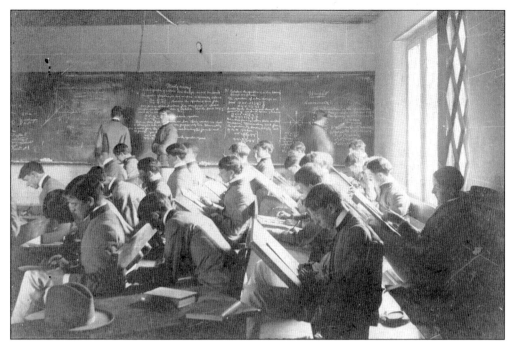

ENGINEERING CLASS, 1899. Until the completion of Smith Hall in 1900, all academic classes were taught in section rooms located in the Barracks. In this class, cadets sit on benches and use wooden boards as desks. During the class period, cadets worked assigned problems at the blackboard. The cadet closest to the camera appears to be napping

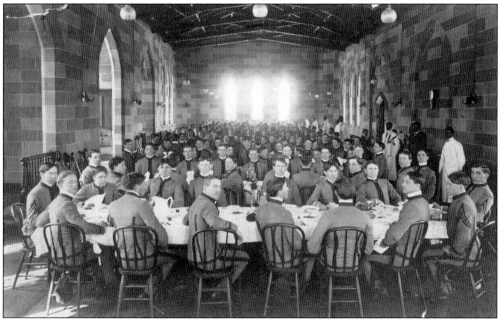

CADETS IN THE MESS HALL, 1900. Since the original building designed by Alexander J. Davis, there have been at least five mess hall structures on the present location. All of the previous structures were destroyed by fire. Cadets have always marched down to the mess hall, and until the mid-1990s, eaten family style.

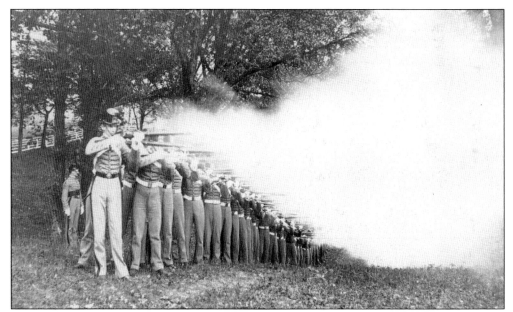

CADET VOLLEY AT THE VMI CEMETERY. Challenges of 19th-century transportation required many colleges to have cemeteries located on campus. The VMI Cemetery was located just beyond the southwest corner of the Parade Ground. Five of the ten cadets killed in the Battle of New Market were interred there until 1912, when their remains were moved to the base of the statue "Virginia Mourning Her Dead." The VMI Cemetery, created in 1878, was discontinued in 1912. Cadets and faculty buried there were moved to the VMI plot in the Stonewall Jackson Cemetery in Lexington.

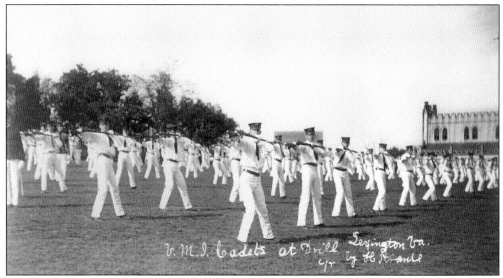

PHYSICALLY FIT, 1900. For the first half of the 20th century, the Cadet Corps performed "Butts' Manual" on the Parade Ground every Wednesday afternoon. Capt. Edmund Luther Butts, U.S.M.A. 1890, authored the official physical fitness manual adopted by the U.S. Army in 1900. At VMI after May 15, the exercise was executed in white "negligee" shirts and white cotton pants, according to the regulations of the day. The original Jackson Memorial Hall (1896–1916) can be seen in the right background.

Three

A NEW CENTURY

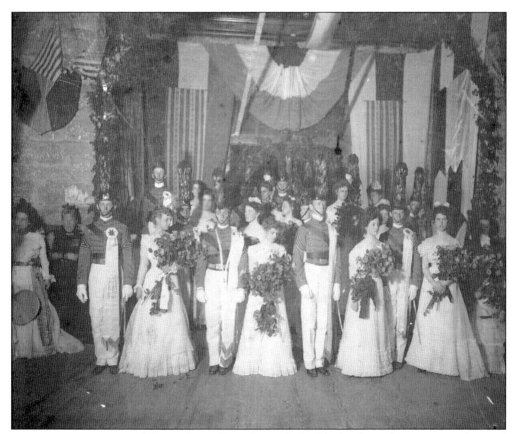

FINAL BALL, 1900. Formal dances have always been the highlight of social activities. Cadets and their dates pause here for an official photograph at the VMI Finals Ball of 1900. Dances at that time were highly structured affairs, with dance cards and marshals leading the event. Future general of the U.S. army George Marshall is the third cadet from the left in the first row.

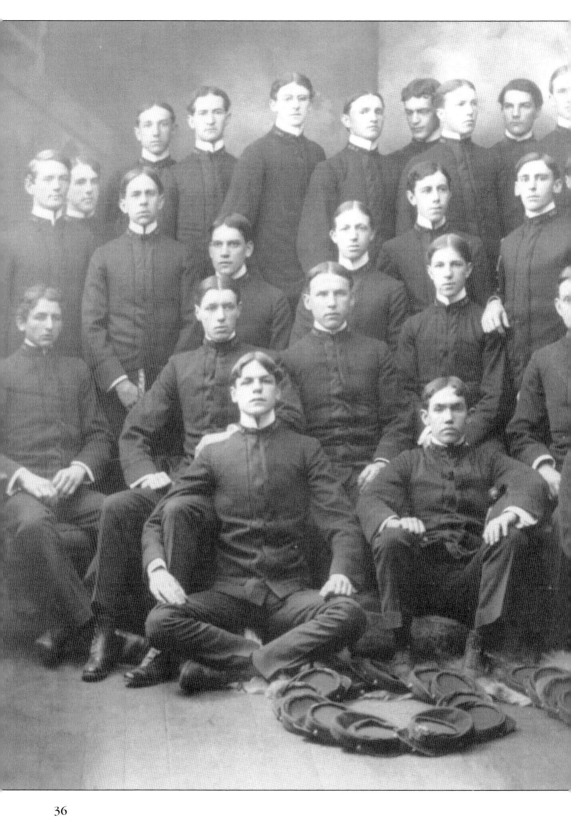

THE FIRST CLASS OF A NEW CENTURY. The Class of 1901 gathered for a formal portrait as graduation neared. Their blue furlough blouse was reserved for wear by first classmen only. They have made their class year with their kepis, "01." Seated in the second row, third from the right is George C. Marshall.

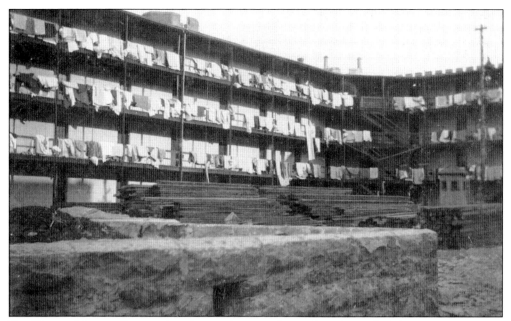

THE HAYS OF MONDAY. In a routine that carries on today, cadets air out their hays (or mattresses) and bed linens on Monday morning. The foundation to the Francis H. Smith Academic Building can be seen in the foreground. Smith Hall stood from 1900 until 1923, when it was removed to allow for the expansion of the Barracks.

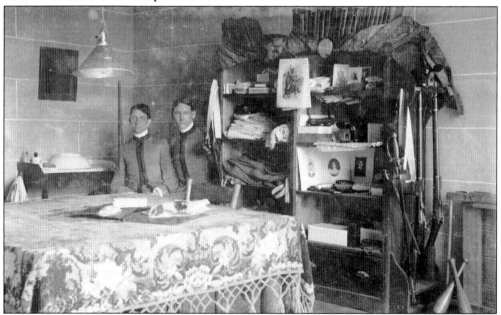

A BARRACKS ROOM, 1902. Cadets William Upshur and Joseph Allen, both members of the Class of 1902, relax in their barracks room. Then, as now, the manual known as the *Blue Book* prescribes exactly how every item was to be arranged in the room. Certain allowances are made for selected personal items, like the photographs of ladies seen in the clothes lockers. Cadet Upshur became a major general in the Marine Corps and received the Medal of Honor for action in Haiti in 1915.

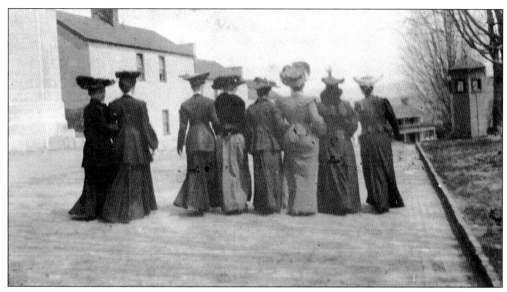

Visiting Calics, 1903. These young ladies in their best hats stroll by Washington Arch. The temporary brick cabins can be seen to the left (where Shell Hall stands today) and the Old Hospital is seen down the hill. Young ladies were referred to as "calics" by cadets as a shortened reference to calico, a colorful clothing fabric.

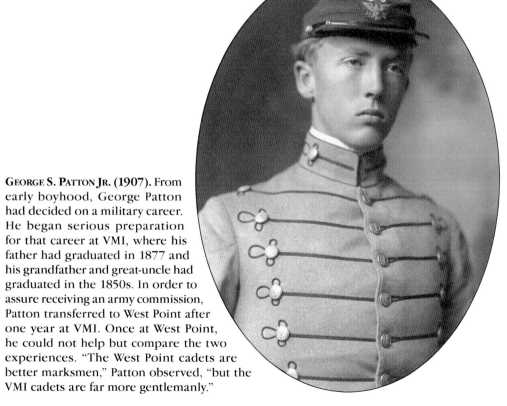

George S. Patton Jr. (1907). From early boyhood, George Patton had decided on a military career. He began serious preparation for that career at VMI, where his father had graduated in 1877 and his grandfather and great-uncle had graduated in the 1850s. In order to assure receiving an army commission, Patton transferred to West Point after one year at VMI. Once at West Point, he could not help but compare the two experiences. "The West Point cadets are better marksmen," Patton observed, "but the VMI cadets are far more gentlemanly."

BARRACKS ROOM NO. 16, c. 1904. Roommates Clement Lathrop and Alfred Upshur provide a glimpse into the sparsely furnished cadet room. Lathrop entered the construction business in Richmond, Virginia, while Upshur became a physician in New York, New York.

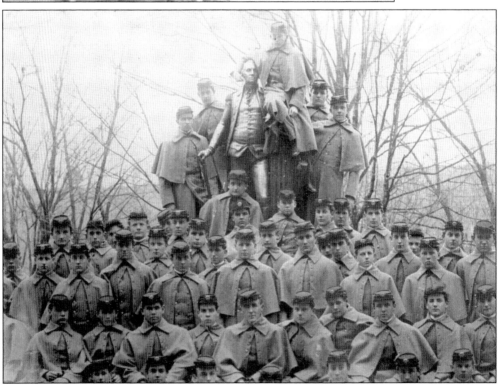

STATUE-LOVING RATS AND PIGEONS. The Class of 1907 chose Houdon's "George Washington," which overlooks Washington Arch, as their perch for this 1904 yearbook picture.

WINTER WEAR. Members of the Class of 1906 had their photograph made while smartly wearing their overcoats. It was around this time that the red lining of the cape was introduced. Many alumni believe the change was made as a tribute to the cadets killed in the Civil War Battle of New Market, but in fact, it was done to make it easier to identify cadets who were in violation of regulations while they were in Lexington.

CADET LIFE, 1905. Four unidentified classmates recorded their life in Barracks. Two cadets are seated on a hayrack (cot), while another hayrack is leaning against the wall to the left. The hayrack design has remained virtually unchanged since its introduction in 1892.

41

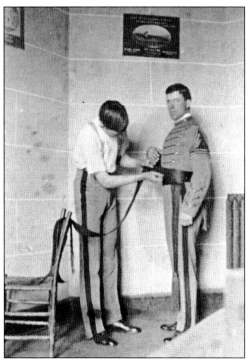

DYKING OUT, 1905. The process of putting on the full dress uniform, complete with sash or cross belts, has been known as "dyking out" since before the Civil War. The expression "to be dyked out" means to be in one's finest attire. At VMI, this requires the assistance of another cadet, usually a freshman (rat) who assists a senior (first). The two refer to each other as dykes, a sort of big brother system where the first class dyke assists the rat in learning the intricacies of VMI life.

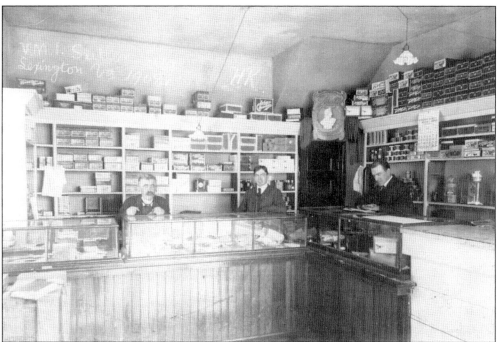

SUTLER STORE, 1908. While uniform items were provided by the Quartermaster Department, various personal items could be found at the Sutler's Store, or Post Exchange (PX). In 1908, the PX was operated by a VMI employee who was also a member of the VMI military brass band. Standing behind the counter are, from left to right, Herman Krause, Charles Higgins, and John Illig. Since the 1960s, the PX has been run by a contracted vendor.

Spelunking, 1905. These three cadets are preparing to explore a cave during some free time. The cadet to the upper right is Richard E. Byrd (1908), who became an admiral in the U.S. Navy and received the Medal of Honor for his explorations of the South Pole. He was the first pilot to fly over both the North and South Poles.

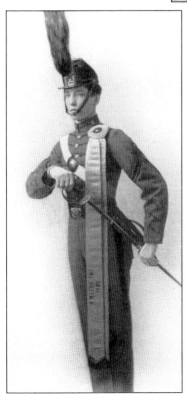

Richard E. Byrd (1908). Byrd is wearing full officer's dress with a long dance ribbon indicating that he was a marshal of the dance. Byrd is one of seven Medal of Honor recipients who attended VMI.

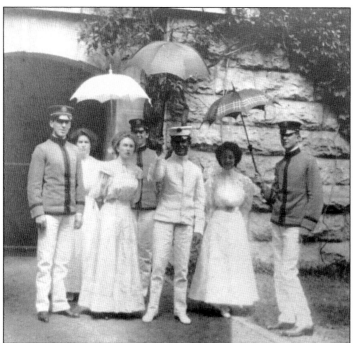

A Spring Outing to Lee Chapel. Four cadets with parasols in hand accompany young ladies to nearby Washington and Lee University to visit the tomb of Robert E. Lee. The cadet in the center is wearing the soon-to-be obsolete summer white uniform. The young lady to his left is wearing a cadet waist plate and belt. The other cadets are wearing the gray fatigue coat—or blouse, as it is referred to today. Their hats have a gold cord chinstrap, which was used only between 1904 and 1909.

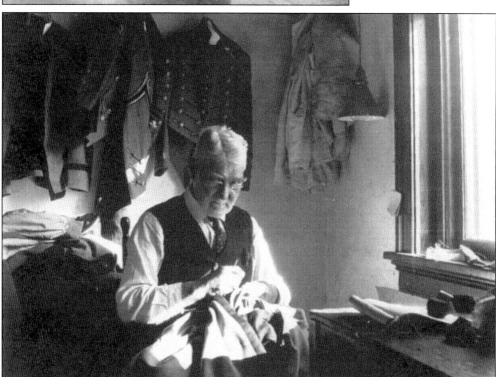

Charles Adams, Post Tailor, 1873–1908. The "Old Man," as cadets called him, was responsible for creating uniforms for hundreds of cadets during his career as post tailor. The first tailor, Samuel Vanderslice, held the position from 1844 to 1873. Until the 1950s, cadet uniforms were cut and assembled at VMI. (VMIAA.)

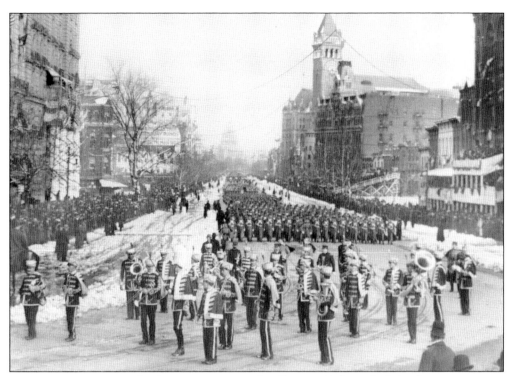

INAUGURAL PARADE, 1909. The inauguration of William H. Taft marked the first occasion on which the Corps marched in a presidential inaugural parade. A special seven-car train took the cadets to Washington, D.C., for the three-day trip. A blizzard the night before threatened to cancel the event, but an army of snow removers cleared the route in time for the parade. Since 1909, the Corps has marched in 13 inaugural parades.

THE GUARD TREE, AROUND 1910. A large hickory tree witnessed the mounting of the first guard team on November 11, 1839, and became the location for the summer camp guard tent. For decades, the Old Guard Tree was a favorite Parade Ground landmark for meeting guests. The first Jackson Memorial Hall (1896–1915), as well as Jackson Arch, can be seen in the background.

45

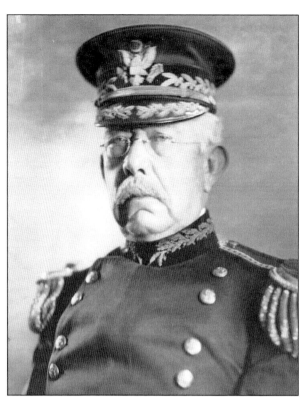

EDWARD W. NICHOLS (1878), THIRD SUPERINTENDENT: 1907–1924. Lt. Gen. Nichols taught mathematics and civil engineering at his alma mater until he was appointed superintendent in 1908. During the challenging years of World War I, he presided over special military training programs at VMI, which included the construction of a complete trench system where the football stadium stands today. In 1924, he returned to teaching. Three years later, Nichols was struck and killed by a rock blasted from a construction site near his home on post. (VMIAA.)

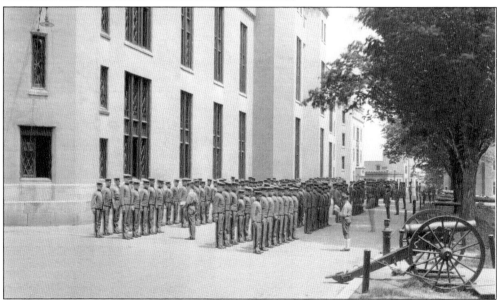

CLASS PARADE (CP), 1915. Until the mid-1980s, cadets formed up in class sections outside the Barracks. The section marcher called the class roll and marched the section to the classroom. When the professor entered the room, the section marcher called the class to attention, saluted, and reported the attendance. Marching to class has been discontinued to provide more time in the classroom, but the tradition of calling a class a "CP," the section marcher taking the roll, and saluting the professor continues.

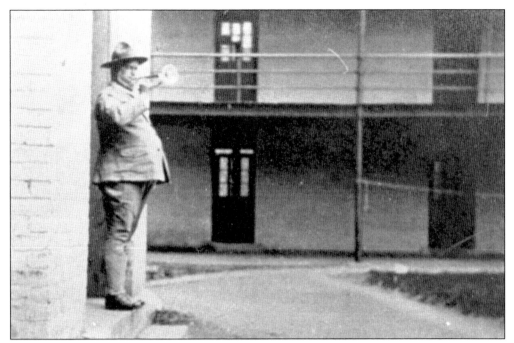

Tom Dulaney, Institute Bugler, 1918. When the use of a bugle was adopted in 1906 to sound reveille and cadet formations, it brought an end to the use of the fife and drum, which had been used throughout the 19th century. Tom Dulaney performed this duty from 1906 to 1924. Since 1985, cadets have served as buglers. Today VMI is one of the last posts where live bugle calls are still used.

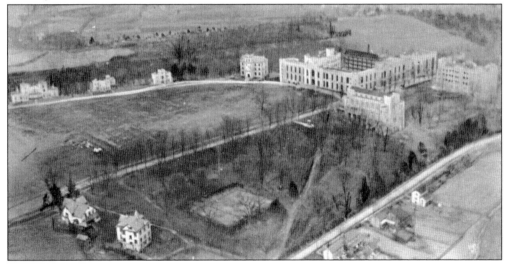

Aerial View, 1920. Taken by Cadet Russell Smith 1920, this early aerial shot reveals the Institute just after World War I. Smith served as a major in the U.S. Army Air Corps during World War II. In the lower left corner is the Pendleton-Coles House (1869) and Freeland Hall (1899). In the mid-ground (from left to right) are the superintendent's quarters (1862), two faculty quarters (1852), the library (1907–1948), Barracks with Smith Hall Academic Building (1900–1923) in the courtyard, Jackson Memorial Hall (1916), Maury-Brooke Hall (1903, now Shell Hall), and Scott Shipp Hall (1918).

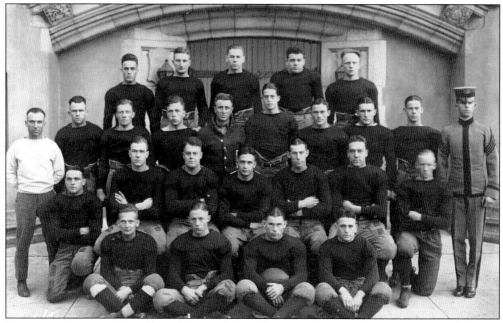

FOOTBALL COMES OF AGE, 1920. The undefeated team of 1920 ushered in an era of formal development of intercollegiate sports at VMI. Wins against Virginia, Virginia Tech, North Carolina, and the University of Pennsylvania brought national attention to the small Lexington College. Seated third and fourth from left on the first row are Jimmy Leech (1921), and Walker Stuart (1921). Leech was elected to the National Football Hall of Fame in 1956. After his graduation from VMI, Stuart received his MBA from Harvard.

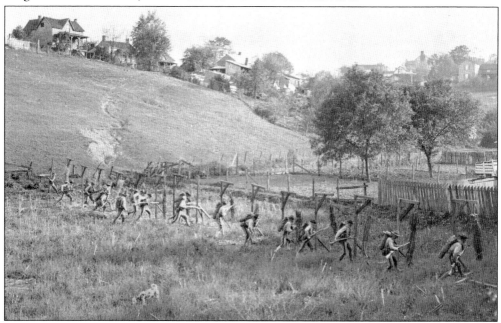

MILITARY TRAINING, 1920. Since the founding of the Reserve Officer Training Corps (ROTC) in 1916, all cadets have been required to be members. Pictured here, cadets practice bayonet drill on what is now Foster Stadium. The spotted dog in the lower left is not impressed.

Four

PEACETIME AND WAR

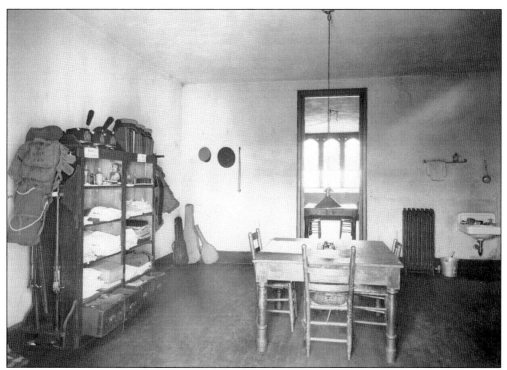

BARRACKS ROOM OF CADET ST. JULIEN R. MARSHALL, 1924. Every item in a cadet room has a prescribed location. At the time of this photograph, personal items were restricted to the top shelf of the wooden locker seen to the left. Note the 1910 field pack hanging over the Model 1917 Enfield rifles in the gun rack. Marshall, a direct descendent of the first U.S. Supreme Court chief justice, became a brigadier general in the U.S. Marines. He graduated from Harvard Law School and served as a legal officer. Marshall was instrumental in the establishment of the CIA.

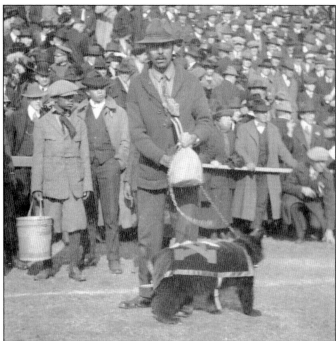

THE VMI BEARS? This early mascot—a bear cub—appeared at the VMI vs. Virginia Tech football game, Thanksgiving 1920. The photograph is captioned "our bare mascot." In 1948, VMI settled on the somewhat safer kangaroo as the official mascot.

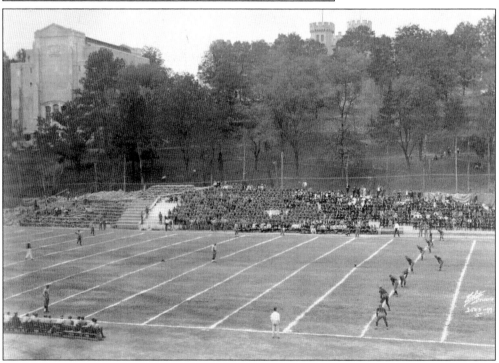

FIRST KICKOFF ON ALUMNI MEMORIAL FIELD, OCTOBER 15, 1921. The newly completed football field was inaugurated with a game against the University of Virginia. Over 7,000 people attended, including the Virginia governor Westmoreland Davis (1877). On the left is Jackson Memorial Hall. The towers of the Barracks (Washington Arch) peer over the covered hillside where Cocke Hall now stands.

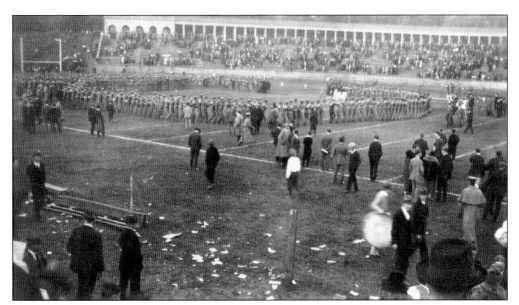

THE SNAKE DANCE. Cadets took the field to perform the "Snake Dance" after their victory over the University of Virginia in 1922. Not particularly military in origin, the dance was an exuberant demonstration of the excitement that football began to generate on college campuses after World War I. This occasion was the inaugural game in the newly dedicated Scott Stadium at the University of Virginia.

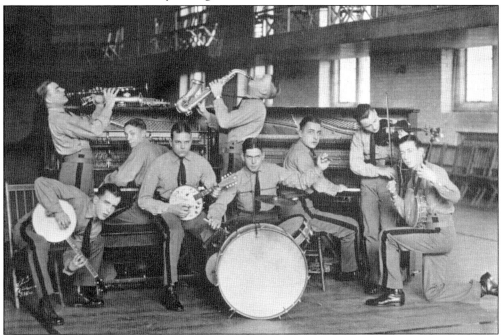

THE "RAMBLING KEYDETS," 1922. Although VMI has never offered a major in music, a number of musical organizations have played an important role in the life of VMI cadets. From guitar and mandolin clubs in the 1890s, to impromptu jazz bands as seen here, music provides welcomed relaxation for cadets. These cadets are practicing in the newly competed Jackson Memorial Hall gymnasium, which is the location of the VMI Museum today.

COMPLETION OF THE OLD BARRACKS QUADRANGLE, 1923. When Alexander Jackson Davis designed the Barracks in 1849, he planned for an enclosed courtyard. However, the size of the Corps at that time did not justify the complete construction of the project, so Davis designed 17-foot modules to be added as the size of the Corps grew. It was not until the 1920s that the Corps grew to a number that required the completion of Davis's original plan.

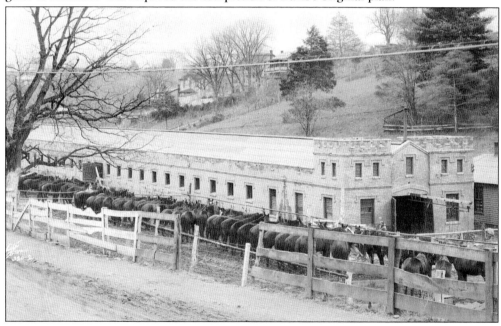

CAVALRY STABLES, AROUND 1924. In 1919, the U.S. Army created a horse cavalry unit at VMI. Facilities to house approximately 100 mounts were built through funds raised by alumni. The arrival of horses brought an era of equestrian competition and polo to the Parade Ground. The actor/comedian Mel Brooks was assigned to the VMI Cavalry detachment during World War II. In 1947, the U.S. Army discontinued the horse cavalry, and the horses left VMI in 1948. A smaller, privately funded riding program has existed since that time. The old stables underwent an adaptive reuse renovation in 2009 and are now part of Kilbourne Hall (ROTC building).

IN NEED OF MORE HORSES. Although not a part of the cavalry manual, stunt riding was a favorite pastime of mounted troops. The cadets seen here are demonstrating a maneuver called the Monkey Drill Pyramid. A separate tract of land known as White's Farm, located nearby the main post, was used for field exercises until the early 1980s.

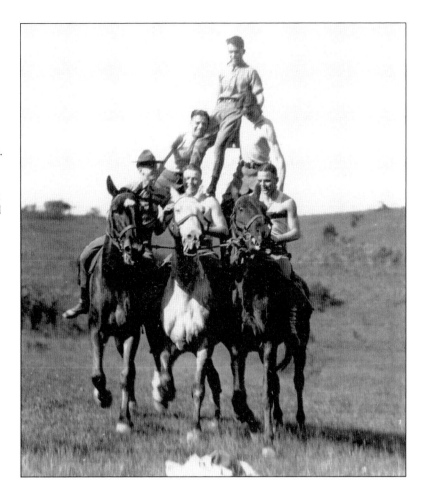

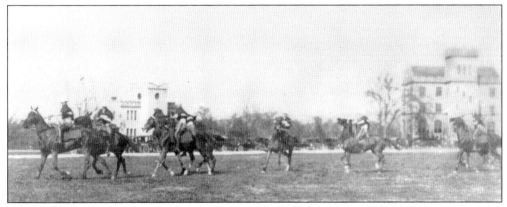

POLO ON THE PARADE GROUND, 1925. Throughout the 1920s, VMI fielded highly successful polo teams, playing many colleges in the Northeast. In the background can be seen the commandant's house (1852, razed in 1966) and the old library (1907, razed in 1948). An occasional match continued to be held on the Parade Ground until the late 1980s.

WILLIAM COCKE (1894), SUPERINTENDENT: 1924–1929. Brigadier General Cocke graduated first in his class. After practicing law in St. Louis, Missouri, he founded the Southern Acid and Sulphur Company in 1907. During World War I, he served in France as a major of infantry. Elected as the fourth superintendent in 1924, his declining health forced his early retirement five years later. The marble statue, *The Spirit of Youth*, was given as a memorial by his widow, Anna Owen Cocke, in 1939.

COCKE HALL, 1927. At the time of its completion in 1927, the 1-million-cubic-foot Cocke Hall was the largest college gymnasium in the country. Originally named 1894 Hall, the name was changed to Cocke 1894 Hall in 1939 after the building's principal benefactor, Supt. William Cocke. That same year the balcony was added to the main floor. From 1933 until after World War II, the VMI armory was also located in the building. (VMIAA.)

COL. ROBERT A. "BUZZ" MARR (1918). Colonel Marr guided development of the civil engineering curriculum to national recognition during his tenure as department head from 1941–1956. Marr established an unsurpassed record in getting his new engineering graduates positions in top firms. He joined the faculty in 1919. Marr's father, also a longtime VMI professor of civil engineering, was a member of the Class of 1877.

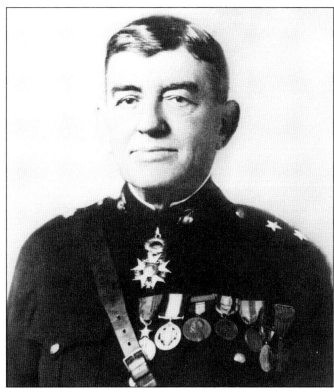

JOHN ARCHER LEJEUNE, SUPERINTENDENT: 1929–1937. An 1888 graduate of the Naval Academy, Lt. Gen. John Archer Lejeune is one of only two nongraduates to serve as superintendent of VMI. (Francis Smith, USMA 1832, is the other.) Lejeune served as commandant of the Marine Corps from 1920 to 1929. When he arrived at VMI, the Great Depression was taking hold. Lejeune's personal relationship with Pres. Franklin Roosevelt helped secure much-needed federal funding for enlarging and modernizing the Institute. Camp Lejeune, North Carolina, is named in his honor.

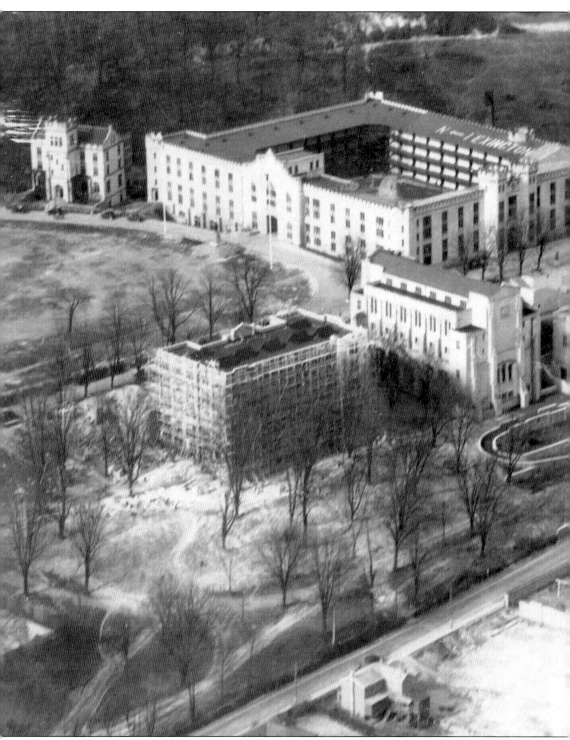

Aerial View, 1930. Only a couple of years before this aerial image was made, the fourth side of Barracks was completed, thus enclosing the courtyard for the first time. A large arrow and letter "N," along with the word "Lexington," was painted on its roof as an aid to airmen.

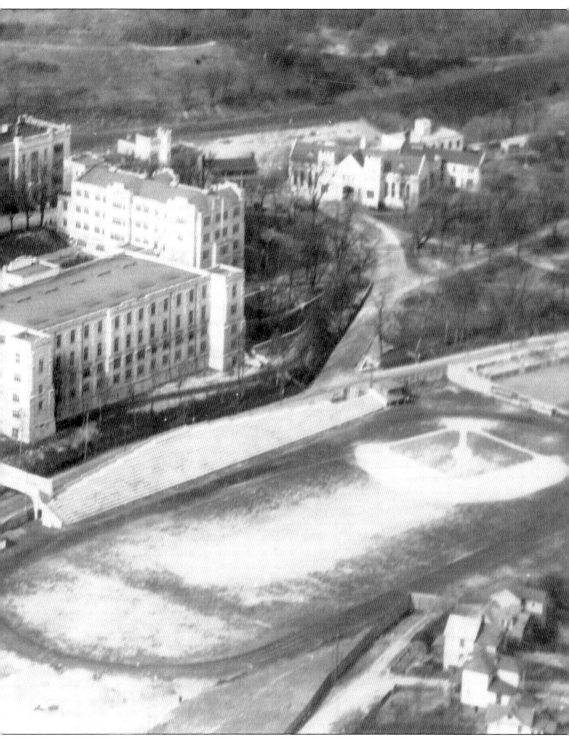

To the left, Nichols Engineering Hall (commonly referred to by cadets as "NEB") nears completion. Constructed in 1931 at a cost of $180,000, the engineering hall underwent a complete $17-million renovation in 2005.

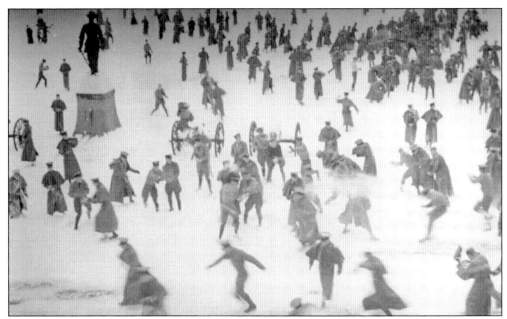

THE GREAT SNOWBALL BATTLE OF 1934. Boredom of winter, or "The Dark Ages," as the cadets call it, is broken whenever enough snow accumulates on the Parade Ground to support a corps-sized snowball battle. That was the case in February 1934 when a near-record snowfall blanketed the Institute. Here a group of cadets retreat to the base of Stonewall Jackson's statue, upper left. (VMIAA.)

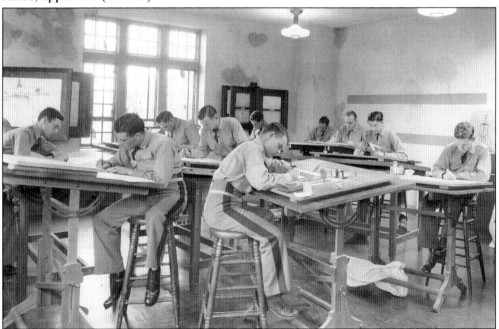

DRAFTING CLASS, 1935. The ability to translate three-dimensional problems into two-dimensional drawings has always been fundamental to the practice of engineering. Until the advent of computer-assisted drafting (CAD) programs, cadets spent many hours meticulously and flawlessly creating detailed drawings.

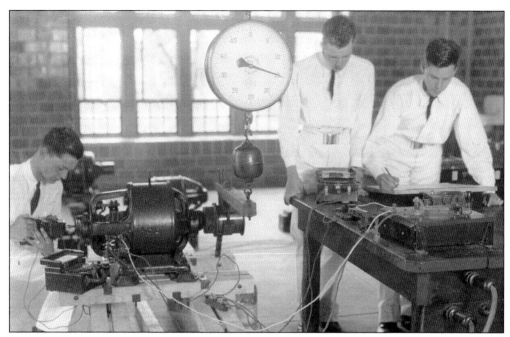

ENGINEERING LAB, 1935. Practical hands-on lab experience and classroom recitation at the blackboard comprised the two main elements of a VMI engineering education through the 20th century. Nichols Engineering Hall, named in honor of Supt. Edward Nichols, was completed in 1932. In 2006, the structure underwent a complete renovation, which configured the facilities for 21st-century engineering instruction.

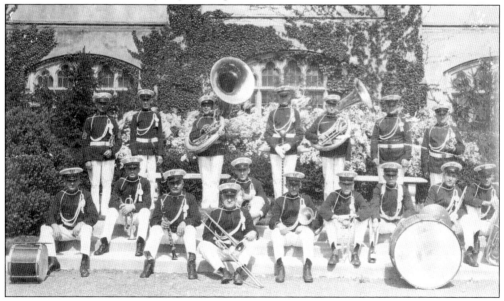

THE VMI BAND, AROUND 1935. From 1839 to 1869, a drummer and a fifer provided martial musical accompaniment for the Corps. In October 1869, the first seven-member brass band was organized. Prior to 1947, the VMI Band consisted of professional musicians employed by VMI. When not playing music at parade or guard mount, the members engaged in other activities such as running the VMI post exchange, mess hall, or laundry.

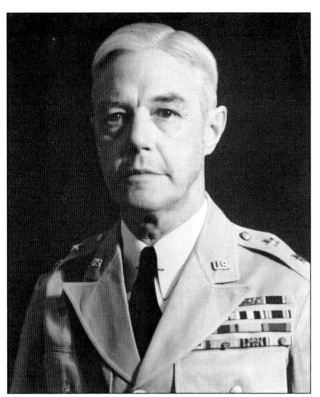

CHARLES KILBOURNE (1894), SUPERINTENDENT: 1937–1946. Lieutenant General Kilbourne became superintendent in 1937 following a distinguished career in the U.S. Army. He was the first person in American history to hold the nation's three highest military decorations: the Medal of Honor, the Distinguished Service Cross, and the Distinguished Service Medal. On December 7, 1941, Kilbourne called the Corps into Jackson Memorial Hall and admonished them not to enlist, but to remain at VMI and complete their education. Within 24 months, many cadets saw their education interrupted for active duty service. In 1946, one year after the return of peace, Lieutenant General Kilbourne retired.

MATRICULATION, 1938. Since 1894, new cadets—rats—arrive about one week earlier than the "Old Corps." Here a group of smartly clad young men arrive at Jackson Memorial Hall to exchange their suits for cadet uniforms. Many of these cadets had their cadetships interrupted by active military service in World War II. Over 4,100 alumni served in the war.

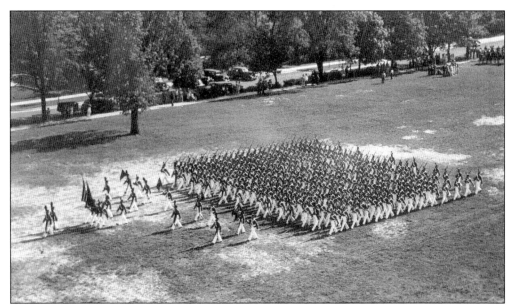

PERSHING SQUARE, 1938. Viewed from the fourth floor of the Barracks, the Cadet Corps performed the Pershing Square, a challenging formation requiring precision movement and flawless execution. This image may have been made during a practice for the filming of the movie *Brother Rat*.

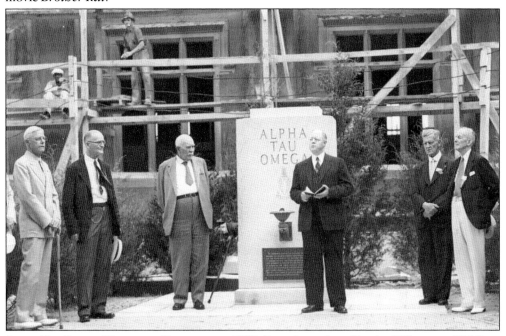

ALPHA TAU OMEGA MONUMENT DEDICATION, 1939. Superintendent Charles Kilbourne (1894), at far left with cane, watched while national officials of the ATO fraternity dedicated a monument commemorating its founding at VMI in 1868. Sigma Nu was also founded at VMI, but neither organization has had a chapter at the Institute since 1912, when all fraternities were banned from post. A few feet to the rear of the monument is Preston Library, then under construction. The library building was dedicated later that same year.

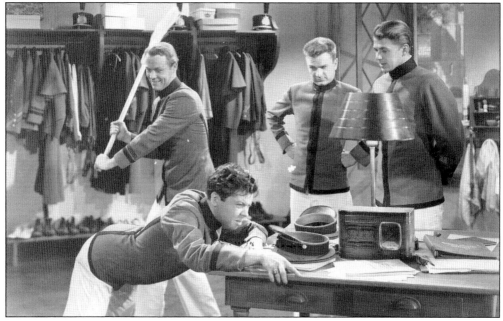

***BROTHER RAT*, A FILM COMEDY ABOUT CADET LIFE, 1938.** During their first class year, two brother rats from the Class of 1932, Fred Finckelhoffe and John Monks, found themselves on an extended period of confinement. With time on their hands, they decided to write a play about cadet life. The play was discovered by producer George Abbott. After a successful run on Broadway, the play was made into a movie by Warner Brothers in 1938. In this scene, Misto, the rat (William Tracey), is "taken in" (welcomed in to the ranks of the "Old Corps") by first classman Billy Randolph (Wayne Morris) while brother rats "Bing" Edwards (Eddie Albert) and Dan Crawford (Ronald Reagan) look on. The cadet room is faithfully recreated for the period. Finckelhoffe and Monks enjoyed successful careers as screenwriters. Their works included the movie *Meet Me in St. Louis* starring Judy Garland and the 1947 James Cagney film *13 Rue Madeleine.* (VMIAA.)

***BROTHER RAT* SOUND STAGE SET.** A fair replication of the Barracks was constructed on the Warner Brothers' lot for filming tight shots. The statue of Stonewall Jackson has yet to be placed on its pedestal, although the Cadet Battery is in place. Much of the exterior filming was done on location at VMI, including parades and baseball games. (VMIAA.)

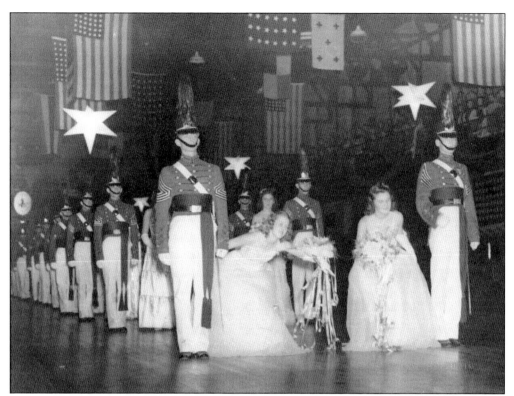

CENTENNIAL BALL, 1939. One of the highlights of the celebration of the 100th anniversary of VMI was the Centennial Ball held in Cocke Hall. In this image, cadets in full dress introduced their dates to the official party. The ladies are exhibiting the "debutante low curtsy."

SATURDAY EVENING POST COVER, NOVEMBER 11, 1939. National attention was focused on the Institute when Cadet Supply captain William Baldwin and Regimental Cmdr. Walter Edens, both Class of 1940, appeared on the November 11, 1939, cover. The full-color feature article celebrated the 100th anniversary of the Institute. Pres. Franklin Roosevelt was scheduled to come to address the Corps on November 11, but the trip was cancelled when Germany invaded Poland on September 1, igniting World War II.

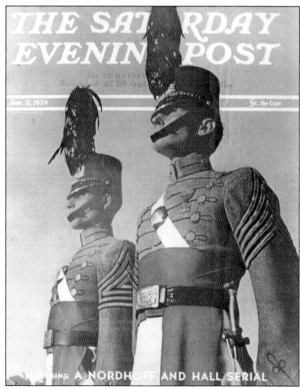

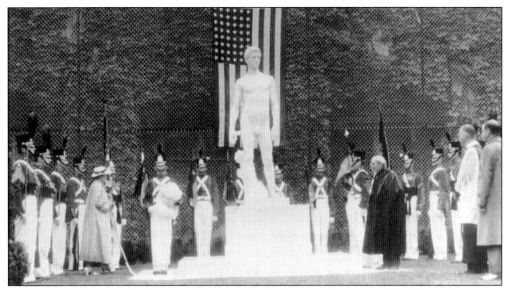

***THE SPIRIT OF YOUTH*, 1939.** Mrs. William Cocke dedicated the statue, *The Spirit of Youth*, in Memorial Gardens in 1939. A heavy rainstorm reduced the crowd to the official party and an honor guard of cadets. The statue, by the celebrated artist Antillio Picarelli, was originally commissioned by Italian dictator Benito Mussolini to commemorate Italian youth who served in World War I. By the time the statue was completed, Mussolini was viewed as an enemy of the United States. The artist refused to send the statue to Italy and subsequently offered it to Mrs. Cocke who purchased it for VMI.

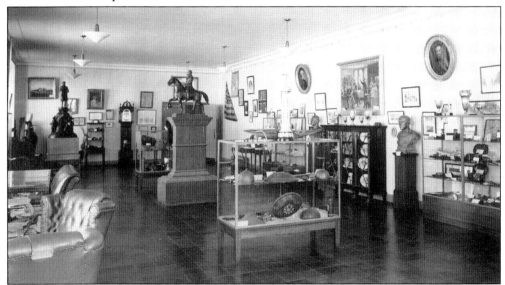

VMI Museum, 1940. Tracing its origin to 1856, the VMI Museum is the oldest museum in Virginia and was one of the first 100 museums in the nation to be professionally accredited by the American Association of Museums. It was located in Preston Library from 1939 to 1969, when it was moved to its current location in Jackson Memorial Hall. The museum collection has grown to more than 13,000 artifacts, the majority of which have been donated by the person historically associated with the item. Seen in the center of this image is the bronze statue "Lee on Traveller" by Frederick Volck, who presented it to VMI in 1870.

Five

EDUCATING CITIZEN-SOLDIERS

GUARD MOUNT, 1943. World War II reduced the number of cadets significantly, but the U.S. Army Specialized Training Program (ASTP) increased attendance. ASTP cadets wore U.S. Army uniforms instead of the traditional VMI uniform, and they were not required to obey all VMI regulations. However, they did share in the pleasure of Guard Mount, as seen in this image. ASTP provided an accelerated undergraduate education to qualified enlisted men in preparation for commissioning.

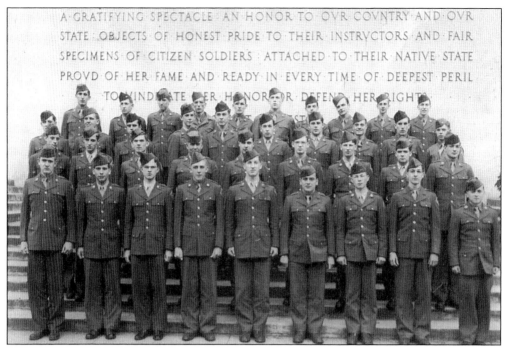

THE END OF THE WAR AND ASTP. The last group of Enlisted Reserve Corps, Army Specialized Reserve Training Program, to attend during World War II had their picture taken on April 27, 1946, their last day at VMI. From 1944 to 1946, the federal program educated 2,148 students at VMI—including writer Gore Vidal. In September 1947, three of those in the picture returned to VMI as third class "bull rats" (academic sophomores who still had to go through the Rat Line experience).

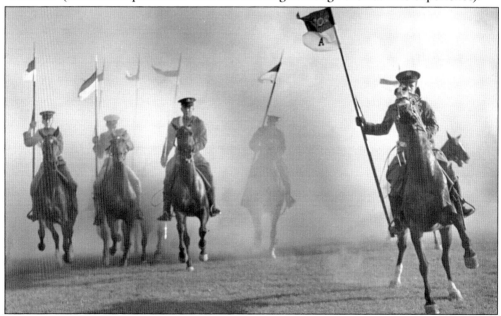

IN THE NICK OF TIME. The Cadet Cavalry created a dust storm as it charged across the Parade Ground. Cadet riders not only became proficient in military drill, but they also participated in civilian horse shows throughout the mid-Atlantic region, often bringing blue ribbons back to Lexington.

RICHARD MARSHALL (1915), SUPERINTENDENT: 1946–1952. Marshall received his commission in the army in 1916. Promoted to major general in 1942, Marshall served as deputy chief of staff to Gen. Douglas MacArthur during World War II, and chief of staff in December 1945. Returning to VMI as superintendent in 1946, Marshall oversaw the return to normal academic and military routine, and the largest corps in history—776 cadets. Many veterans returned to complete their education on the G.I. Bill. During Marshall's tenure, the Barracks was enlarged to accommodate the growth of the Corps, horses left the Institute, and tanks arrived.

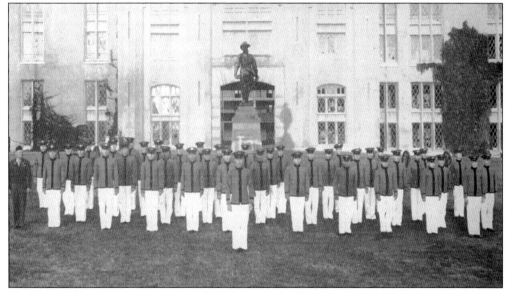

THE FIRST CADET REGIMENTAL BAND, 1947. Prior to 1947, music for parades and guard mount was provided by the VMI Post Band, a group of VMI employees who played in the band as one of their many duties. The first band completely comprised of cadets was formed in 1947. Today the VMI Regimental Band consists of 150 cadets representing all four classes. The award-winning unit performs internationally and logs an average of 10,000 miles each year while representing the Institute. (VMIAA.)

THE LAST "RUNNING THE GAUNTLET" BREAKOUT, 1948. For most of their freshman year, the new cadet (known as a "rat") experiences an orientation period called the Rat Line. The rigid structure and restrictions of the Rat Line end with one final event called "breakout," after which the rats are recognized by the old cadets as full members of the Corps. For the first part of the 20th century, breakout consisted of the tradition of "running the gauntlet" —a formation where the old cadets lined up and took a strike at a rat as he rushed past. Breakout has evolved over the past century. Today it consists of a series of supervised, structured activities designed to build class unity and spirit.

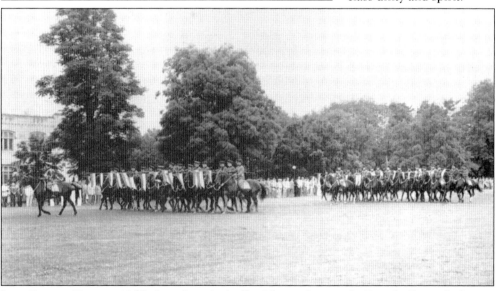

LAST CAVALRY REVIEW, 1948. Seen here in its final formation on the Parade Ground, the era of the Horse Cavalry ended at VMI in 1948. The army had maintained a cavalry unit at the Institute since July 7, 1919, when 100 mounts arrived. In the wake of World War II, horses would be replaced by mechanized vehicles. As the last horses left the Institute, the first unit of tanks arrived. (VMIAA.)

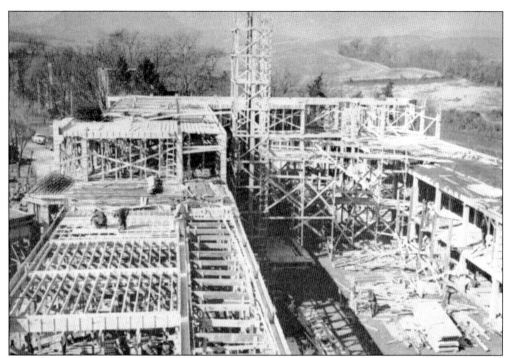

BARRACKS ADDITION, 1949. The end of World War II and the return of veterans to the college applicant pool required a major addition to the original Barracks. The structure, still called "New Barracks" by the Corps, initially housed administrative offices and classrooms as well as cadet rooms. Today it is used exclusively for cadet housing. The main arch into the courtyard was officially named Marshall Arch in honor of Gen. George C. Marshall (1901), on May 15, 1951.

DABNEY COLEMAN, 1953. Emmy and Golden Globe award-winning actor Dabney Coleman arrived at VMI in 1949. Several members of Coleman's family preceded him at VMI, including his father, M. R. Coleman 1921. After his third class year, Coleman left VMI, ultimately studying acting at the Neighborhood Playhouse School of Theater in New York City. Coleman is a loyal supporter of the Institute. (VMIAA.)

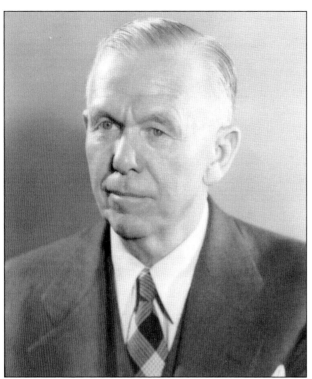

GEORGE CATLETT MARSHALL 1901. George Marshall graduated as the top-ranking cadet in 1901. Appointed chief of staff of the U.S. Army in 1939, he served in that capacity through World War II. Called the "organizer of victory" by Winston Churchill for his leadership of the Allied forces, Marshall was chief military advisor to Pres. Franklin Roosevelt. After the war, he was appointed U.S. Secretary of State, U.S. Secretary of Defense, and president of the American Red Cross. In 1953, Marshall was awarded the Nobel Prize for Peace for his role in developing the European Recovery Act, better known as the Marshall Plan.

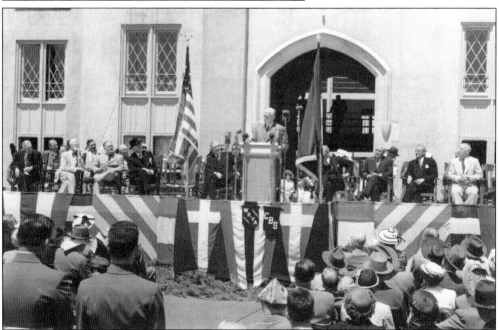

MARSHALL ARCH DEDICATION. May 15, 1951, was officially declared "Marshall Day" at VMI. On that occasion, Marshall Arch was dedicated. U.S. Secretary of Defense George C. Marshall (1901) is seen here speaking at the event. In 1963, the George C. Marshall Research Library and Museum was opened on the VMI Post. In 2009, the Center for Leadership and Ethics in Marshall Hall was dedicated.

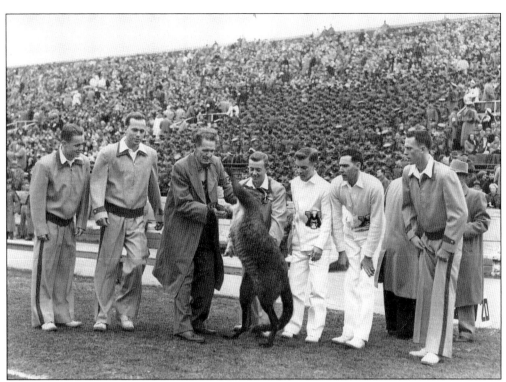

MOE THE KANGAROO, VMI MASCOT. The idea of having a live kangaroo as the VMI mascot originated in the late 1940s, and the first "Moe" appeared during the 1948 football season. The animal was owned and cared for by VMI employee Mike Brown, who also ran a small zoo near Lexington. The VMI cheerleader at the left is John Knapp (1954), who became the commanding general of the 80th Division, Training, USAR, and twelfth superintendent of VMI. After a series of live "Moes" filled the role, a costumed mascot took the field in 1972. (VMIAA.)

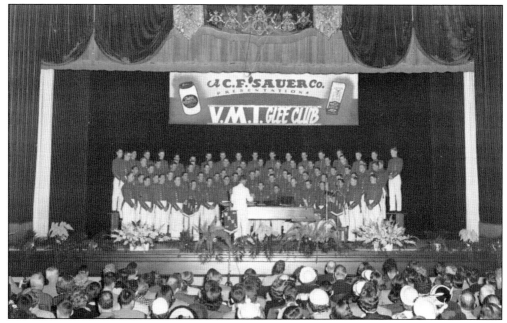

THE VMI GLEE CLUB, 1951. Although small singing groups have always been a popular extracurricular activity with cadets, it was not until after World War II that English professor Herbert Dillard (1934) officially organized the VMI Glee Club. Spring concert trips afforded a rare opportunity to travel, often to joint concert appearances with women's colleges. A much sought-after performing group under Dillard's direction, Glee Club concerts drew large audiences, as shown here during a Richmond performance.

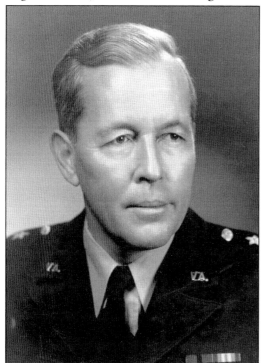

WILLIAM MILTON (1920), SUPERINTENDENT: 1952–1960. Milton was the first superintendent since Francis Smith who did not have a military career. He pursued a career in engineering and business with General Electric. Milton was the first director of a privately run nuclear power plant, Knolls Atomic Power Laboratory, in Schenectady, New York.

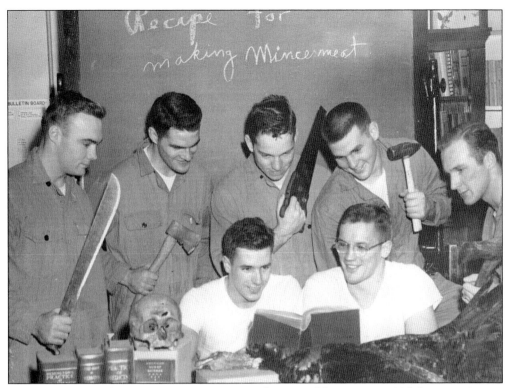

VMI AND VIRGINIA TECH, FOOTBALL RIVALS? From the start of the series in 1894, for over 70 years *the* sporting event in Virginia was the annual Thanksgiving Day, VMI vs. Virginia Tech game. This photograph captured some VMI biology majors in 1953 preparing a pregame recipe of "Mincemeat Turkey Pie." The two schools last played football against each other in 1981.

A MONUMENT TO A TREE. The posting of the first cadet guard took place on November 11, 1839, near a hickory tree that became known as the Guard Tree. During summer military encampments, the cadet guard tent was pitched in the shade of the landmark. The last vestige of the ancient hickory was removed in May 1954. A monument, designed by VMI graduate William Simpson (1924) [at left in photograph with cadet] was created to mark the spot. The tree is listed in the *Remarkable Trees of Virginia* register.

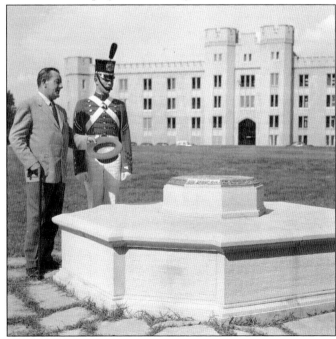

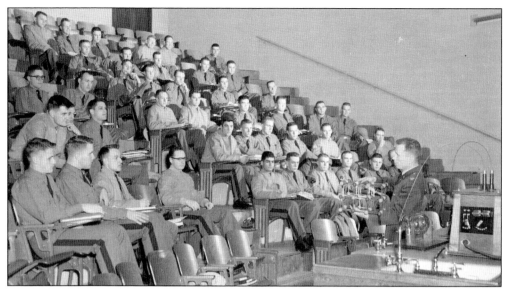

PHYSICS LECTURE, 1955. Col. James B. Newman (1939) holds class in the newly completed physics building, Mallory Hall. Newman began his teaching career at VMI immediately following his graduation. He retired in 1969 as head of the department. The building, named after longtime professor of physics Col. Francis Mallory (1889), underwent a $13-million renovation in 2008.

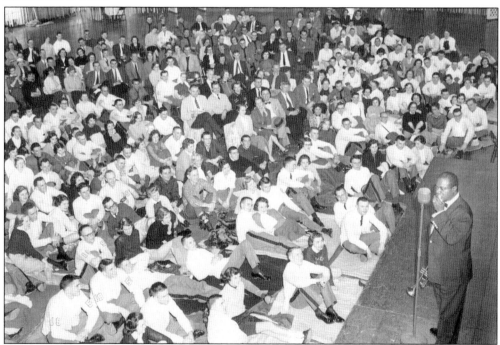

"BLANKET" CONCERT, 1957. Dance weekend during most of the 20th century consisted of an informal dance on Friday night and a formal dance on Saturday. Occasionally the Friday night affair was a "blanket" concert. Cadets spread their bright red issued comforters on the floor of Cocke Hall, and they and their dates enjoyed nationally acclaimed musicians. In this image, the celebrated jazz trumpeter Louis Armstrong is performing.

MATRICULATION, 1957. Cadetship officially begins with the signing of the *Matriculation Book* on matriculation day. Since the first cadet penned his name—John S. L. Logan—on November 11, 1839, over 20,000 young men and women have repeated the ritual.

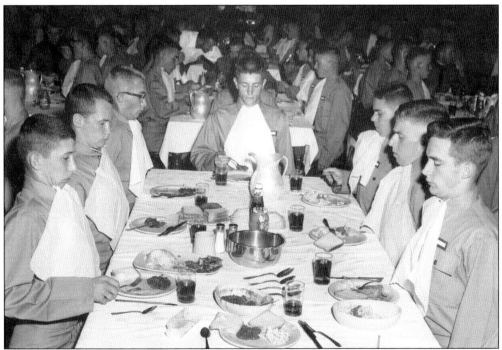

FORMAL DINING FOR THE RAT CLASS, AROUND 1957. The decades following World War II ushered in a more structured Rat Line experience. In Crozet Hall (the mess hall), rats ate at "attention" under the watchful eye of an upperclassman. Since the early 1990s, rat restrictions in the mess hall have been relaxed in an effort to assure proper nutrition. In 2007, Crozet Hall was enlarged and completely updated.

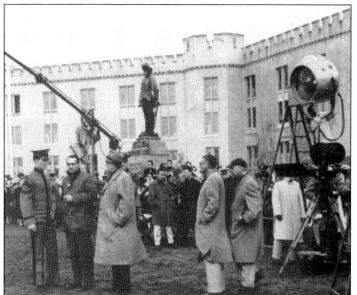

ANOTHER VISIT FROM HOLLYWOOD. Actor Pat Boone and members of the crew of *Mardi Gras* discuss a scene on the Parade Ground during the filming in 1958. The VMI Band was flown to New Orleans to appear in the scenes filmed there. Gary Crosby, Tommy Sands, and Dick Sargent had also appeared as "cadets" in the film. (VMIAA.)

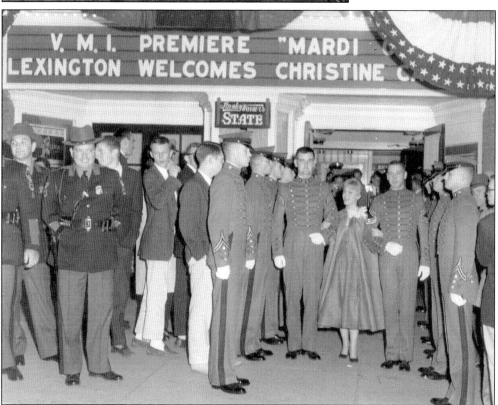

MARDI GRAS **PREMIERE, 1958.** Cadets provided an honor guard for actress Christine Carère at the Lexington premier of *Mardi Gras*. For most cadets, Carére's visit was more memorable than the film. She visited the Barracks, addressed the cadets in the mess hall at dinner, and "took the review" (observed the cadets marching to the mess hall) with the 1931 commandant, Glover S. Johns Jr.

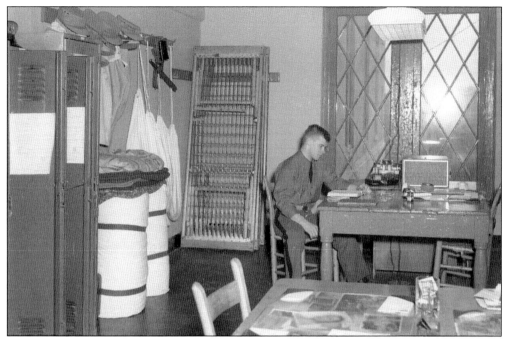

BARRACKS ROOM, 1958. An unidentified cadet studies in his barracks room. The sturdy desks in the center of the room had been in service for over 50 years by the time this image was made. They continued to be used until the late 1980s. Notice the hayracks (cots) stacked in the corner and the hays (mattresses) rolled and stacked along the wall, identical to how they are depicted in the 1855 sketch on page 14.

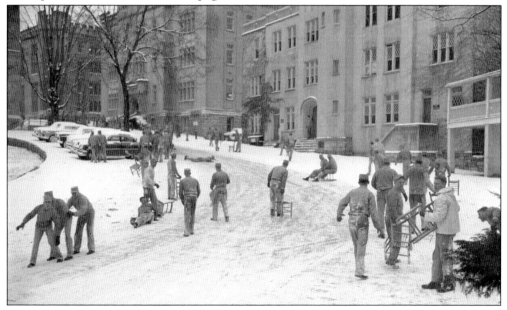

FIELD EXPEDIENCE, 1958. A barracks room chair, the hill leading to the mess hall, and snow combined to provide an ideal diversion from the doldrums of winter. In the background can be seen, from left to right, Scott Shipp Hall, the Barracks, Maury-Brooke (now Shell) Hall, Carroll Hall, and the Old 1848 Hospital.

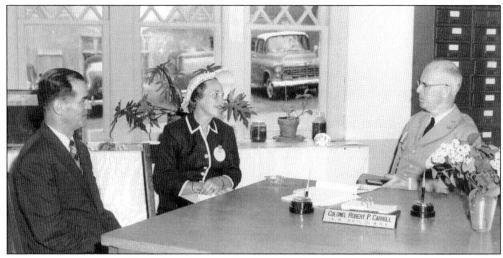

PARENTS WEEKEND, 1958. Col. Robert P. "Doc" Carroll meeting with parents in his office during the first-annual Parents Weekend, May 1958. Doc Carroll came to VMI in 1928 and immediately began to develop a curriculum, which became a pre-med oriented department of biology. The one-armed, tobacco-chewing professor was beloved by several generations of cadets who went on to distinguished medical careers—"Doc Carroll's Boys." Col. Carroll retired in 1968. The Cadet Academic Support Building—previously the biology building—is named in his honor.

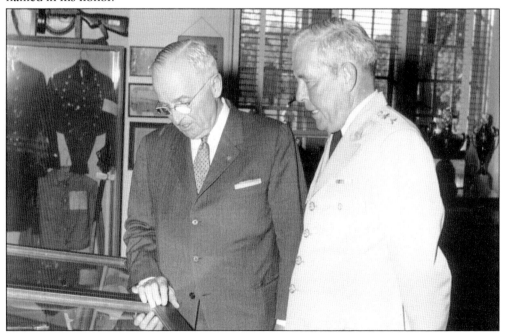

PRESIDENT TRUMAN VISITS THE VMI MUSEUM, 1960. On a brief visit to Lexington, former president Harry Truman took time to view the VMI Museum with Supt. William Milton. Truman was a strong supporter of Gen. George Marshall. In 1952, President Truman had telephoned Superintendent Milton suggesting the concept of housing General Marshall's papers at VMI. Twelve years later, the concept would be realized with the opening of the George C. Marshal Research Library. (VMIM.)

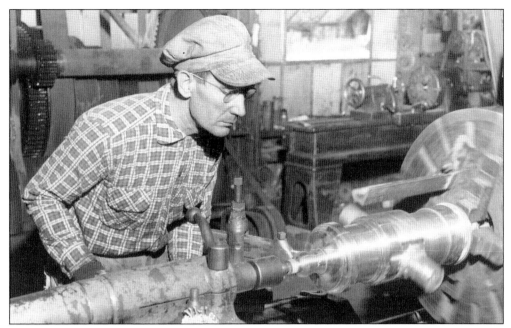

THE BIRTH OF LITTLE JOHN II. A workman at the Buena Vista Foundry controlled the lathe as the brass barrel of the new "touchdown" cannon, Little John II, took shape. Modeled after a 1750 British Howitzer, the 3/5th scale gun was cast from 100 empty brass 75mm shell casings, which had been fired from the VMI evening gun. First used at the opening game of the 1958 football season, Little John II can still be heard at every home football game. The original Little John was a cobbled together cannon made by the Corps from welded pipes. It was retired after the undefeated football season of 1957 and is now in the VMI Museum collection.

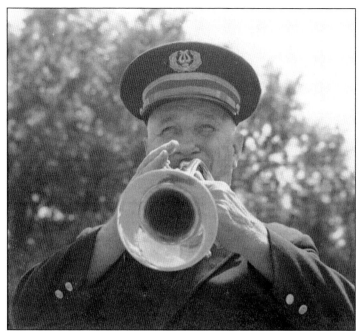

"BILL THE BUGLER." When the Tom Mix Circus came to Lexington in 1937, it left with one less musician. Wilbur Swihart stayed behind to become the VMI bugler. "Bill the Bugler" saved untold numbers of cadets from being late to formation by drawing out the last note of Assembly longer than seemed humanly possible. In the late 1980s, CBS journalist Charles Kuralt's *On the Road* television program chronicled Swihart's special place at VMI.

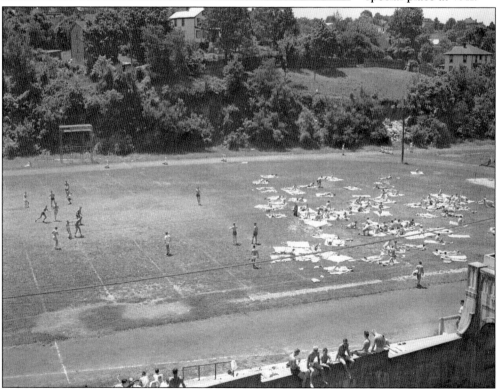

"L.A. BEACH" AROUND 1960. Spending the afternoon with a book, blanket, and Frisbee while enjoying the sun on the football field was a rare spring treat. Engineering cadets, with a mixture of contempt and envy, dubbed the field "L.A. Beach." The "L.A." stands for liberal artist; engineering cadets spent their afternoons in laboratories.

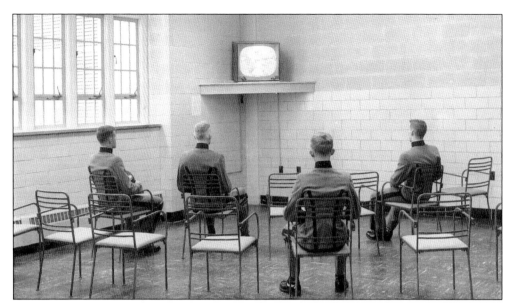

ONE TELEVISION, ONE CHANNEL. In the early 1960s, a major leap forward in the use of technology in the classroom occurred when the first television set was installed in Scott Shipp Hall, the liberal arts building. It is obvious that the cadets in this picture are enjoying the experience. Fully computerized smart classrooms are the standard today.

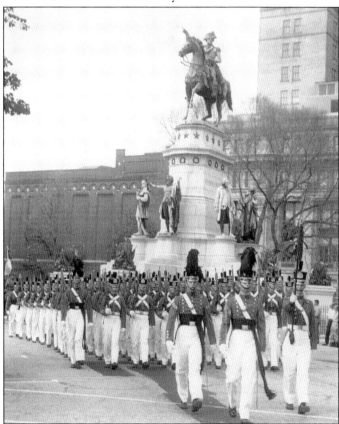

CIVIL WAR CENTENNIAL, 1961. The Cadet Corps participated in the opening ceremonies of the Civil War Centennial at Capital Square, Richmond, in the spring of 1961. Exactly 100 years earlier, the Corps had been ordered to Richmond to serve as drill instructors for raw Confederate recruits who were streaming into the capital city.

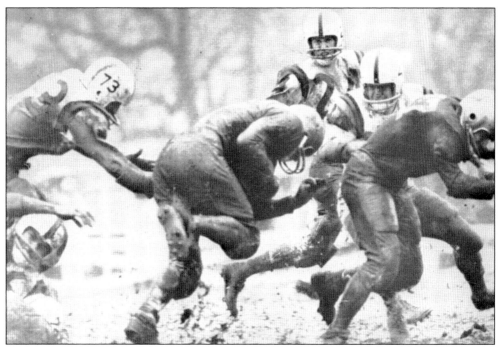

FOOTBALL, 1961. This photograph shows VMI vs. Virginia Tech on Thanksgiving Day 1961. The game was played at Victory Stadium in Roanoke in heavy rain; the field was described in the 1962 yearbook as being "a wind-swept, rain-drenched quagmire." VMI upset Tech, 6-0.

JONATHAN DANIELS, CIVIL RIGHTS MARTYR. Jonathan Daniels (1961) was elected valedictorian by his class. After attending graduate school at Harvard and then Episcopal Divinity School, Daniels went to Alabama as a civil rights worker in the summer of 1965. In August of that year, he was gunned down in Hayneville, Alabama, while protecting the life of a teenage African American girl. The Episcopal Church added the date of his death to its Calendar of Lesser Feasts and Fasts. In England's Canterbury Cathedral, Daniels' name is among the 15 honored in the Chapel of Martyrs. At VMI, there is a courtyard and an archway into the Barracks named in his honor, commemorating his life at the Institute.

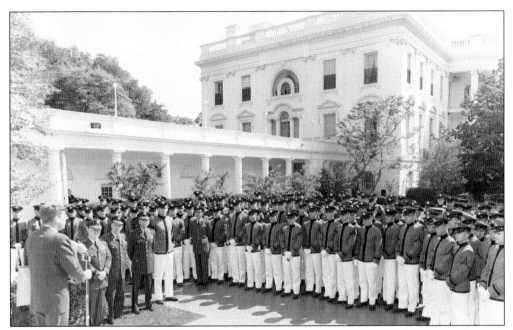

A Visit to the White House, 1963. Pres. John Kennedy greeted a group of cadets in the Rose Garden outside the Oval Office in the spring of 1963. The cadet standing beside the officers on the left is Cadet Regimental Cmdr. Josiah Bunting (1963). He was awarded a Rhodes Scholarship upon his graduation from VMI and served as VMI superintendent from 1995 until 2003. During his tenure as superintendent, he also served as professor of humanities. Bunting was responsible for overseeing the preparations for and the enrollment of the first female cadets in 1997.

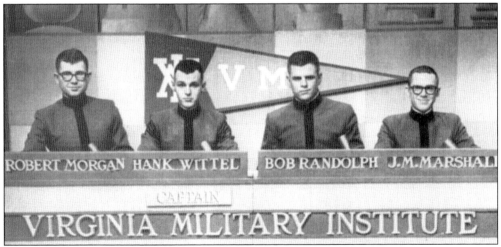

General Electric College Bowl Team. On November 29, 1964, the VMI team set an all-time scoring record on the popular 1960s television game show *College Bowl.* They amassed 400 points out of a possible 420, beating Queens College of New York. Pictured from left to right are Robert Morgan (1965) Frederick Wittel Jr. (1965); Robert Randolph IV (1967); and John Marshall (1965). Bob Morgan pursued a career in law. Hank Wittel became an executive with Herman Miller, Inc. Bob Randolph received a Rhodes Scholarship, and John Marshall became a Texas District Judge. (VMIAA.)

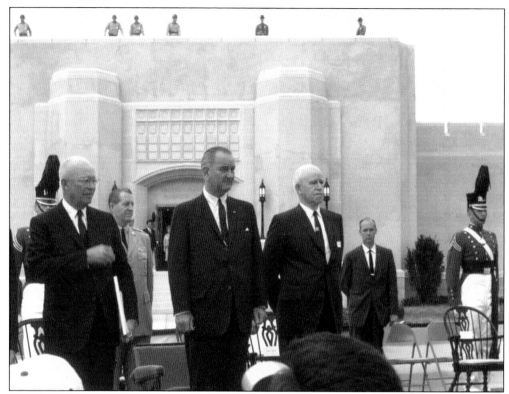

MARSHALL RESEARCH LIBRARY DEDICATION, 1964. Pres. Lyndon Johnson, former president Dwight D. Eisenhower, and Gen. Omar Bradley gathered to dedicate the George C. Marshall Research Library and Museum. For many in the Cadet Corps on that hot May 23rd day, the most memorable moment of the president's remarks came when he granted amnesty to the Corps, erasing any demerits and confinement they may have had at that time. The research center, focusing on the life and times of General of the U.S. Army Marshall (1901), is operated by the Marshall Foundation. (VMIAA.)

PRESIDENT JOHNSON'S REVIEW OF THE CORPS, 1964. Pres. Lyndon B. Johnson and Supt. George R. E. Shell reviewed the Corps of Cadets at the dedication of the Marshall Library on May 23, 1964. A special group of the tallest cadets were arranged for inspection by the 6-feet-3.5-inch president. The cadet sergeant on the left is Thomas Davis (1964) who served VMI as a professor of history for over 30 years.

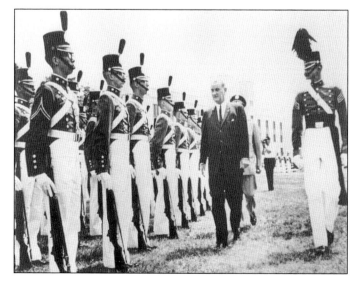

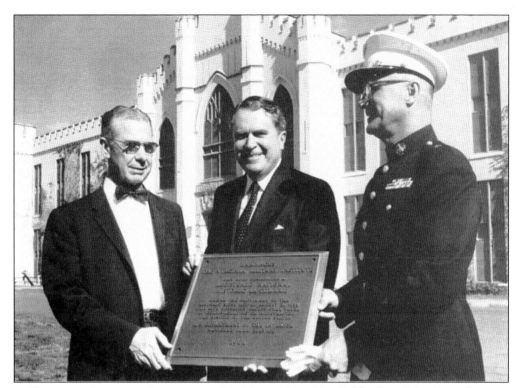

A NATIONAL HISTORIC LANDMARK. On November 11, 1966, the VMI Barracks was designated a National Historic Landmark by the U.S. Department of the Interior. Sam Weems (left), superintendent of the Blue Ridge Parkway, presented the plaque to Carter Burgess (1939) [center], chairman of American Machine and Foundry Company, and Supt. R. E. Shell (1931). (VMIAA.)

FORMAL INSPECTION "ON THE BRICKS," 1966. Weekly formal inspection was a standard of cadet life into the 1980s. The inspection required every cadet to prepare every detail of his uniform, weapons, and personal appearance to pass the scrutiny of the inspecting officer. New Barracks, built in 1948, can be seen in the background. To the left of New Barracks, a construction fence indicates that work had begun on Lejeune Hall, which was dedicated in 1968. Even though the bricks were paved over years ago, the term is still used to refer to the area in front of the Barracks.

INTEGRATION AT VMI. Larry H. Foster (1972) became the first African American cadet when he and four other black cadets matriculated on August 21, 1968. After completing his freshman year, Cadet Foster tragically drowned on July 29, 1969, while tubing on the Maury River at Goshen Pass. It is ironic that he held the James H. Maxwell Scholarship, which was established in 1921 to honor the memory of Cadet Maxwell who had drowned in the Maury River during his cadetship in 1881. Three African Americans graduated in 1972. Philip Wilkerson became an army pilot and retired as a colonel; Harry Gore received a commission in the U.S. Air Force, became a pilot and retired as a lieutenant colonel; and Richard Valentine pursed a graduate degree and a career in communication engineering. (VMIAA.)

LEJEUNE HALL NEARING COMPLETION. In 1968, the first building exclusively designed for cadet social activities was completed. The new facility housed the post exchange, bookstore, television room, billiard tables, a bowling alley, and featured a ballroom designed to accommodate dances, lectures, and films. It was named in honor of Lt. Gen. John A. Lejeune USMC, the fifth superintendent of VMI. The original Lejeune Hall was demolished in 2006 to make room for the expansion of the Barracks. A new Lejeune Hall was incorporated within the new structure.

THE NEW MARKET MEDAL. Gen. Lemuel Shepherd (1917), former commandant of the U.S. Marines Corps, received the New Market Medal from his alma mater on Founders Day, November 11, 1971. The medal recognizes an individual who has demonstrated the qualities of devotion, honor, duty, and leadership. Designed by noted artist Pierre Daura, the coveted award has only been presented 12 times since its creation in 1962.

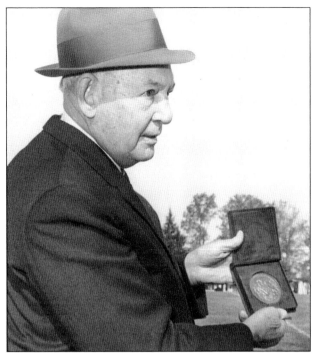

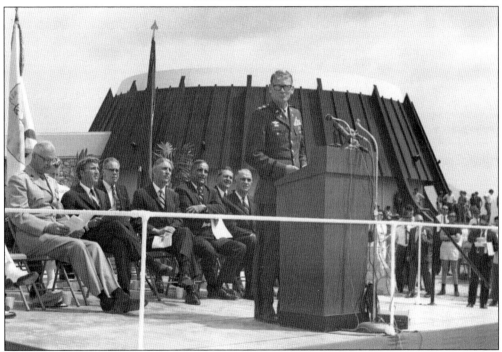

HALL OF VALOR MUSEUM DEDICATION, 1970. Medal of Honor recipient Col. Edward Schowalter (1951) addressed a large crowd at the dedication of the Hall of Valor, the VMI museum facility at New Market Battlefield State Historical Park. The park, a bequest of George R. Collins (1911), opened to the public in 1967. Located 80 miles north of VMI, the 300-acre park includes the historic 1850s Bushong Farm.

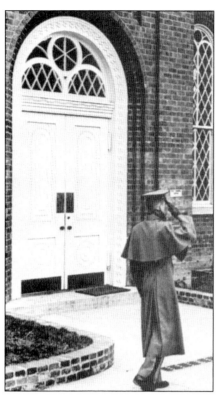

SALUTING A LEADER. For generations, many cadets have rendered a salute as they pass Lee Chapel, the final resting place of Gen. Robert E. Lee, located on the grounds of neighboring Washington and Lee University. Lee served as president of the college from 1866 to 1870. The tradition of saluting is still practiced by many cadets.

A VISIT TO THE BARBER, 1970. Haircuts are a staple of cadet life. For much of the 19th century, cadet haircuts were provided by a member of the mess hall staff who went to the barracks rooms to perform the service. Early in the 20th century, the size of the Corps made this arrangement impractical and an official barbershop was opened in the Barracks. New cadets find themselves visiting the barber's chair several times a week. While the only style available to fourth classmen is limited to "short," upperclassmen have a bit more say in the process.

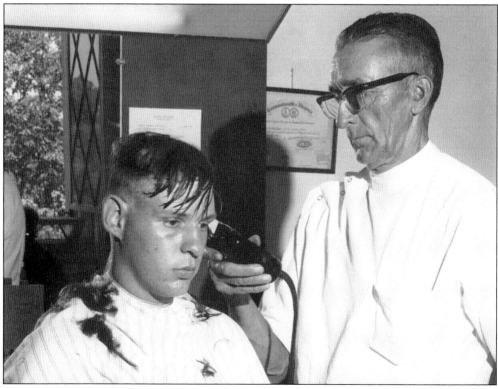

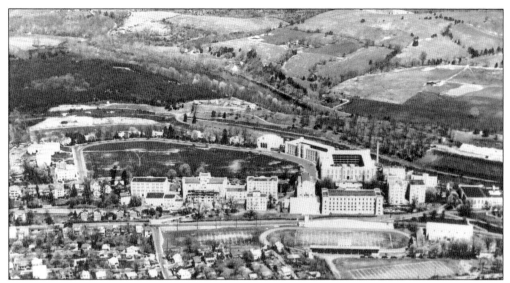

AERIAL VIEW, 1970. By the 1970s, the 12-acre Parade Ground was completely encircled with academic, administrative, and residential buildings. To the left, Moody Hall (alumni building), Smith Hall (administration), and the Marshall Research Library face toward the massive Barracks at the right end of the Parade Ground. Senior administrative and academic housing lines the upper edge, while academic row extends along the lower edge. (VMIAA.)

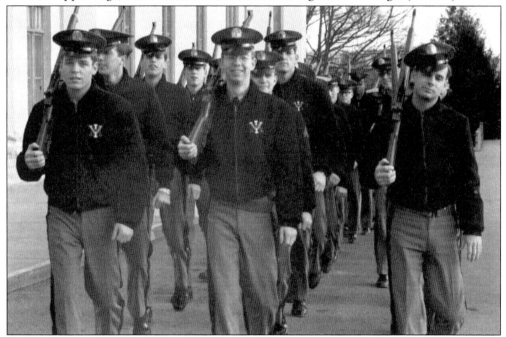

PENALTY TOURS. For over 100 years, "PTs," as they are called by cadets, have been a major part of the disciplinary system—more for some cadets than others. Originally called "punishment tours," cadets found guilty of infractions must march in formation with shoulder arms for a prescribed period of time until all of the "tours" have been walked. PTs, along with demerits, confinement, and dismissal, are the main disciplinary techniques available to the commandant's office.

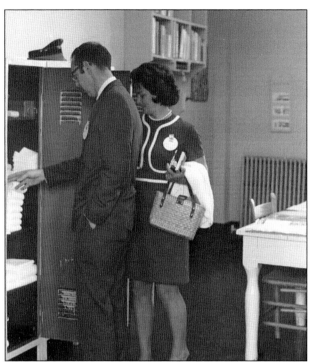

JUST LIKE HOME. Parents inspecting their son's barracks room during the 1971 Parents Weekend appear amazed at the orderliness of his locker. Regulations governing cadet life, including the arrangement of every detail of the cadet room, are documented in the *Blue Book*—a reference manual found in every room. Until the late 1980s, each cadet room was furnished with a metal locker for small items, a wall locker for hanging uniform items, a bookshelf (seen in the rear of this image), a desk, chair, cot, and mattress. Each room has a card rack in which to place the cadet's academic schedule (visible in the rear of this image) and a rifle rack.

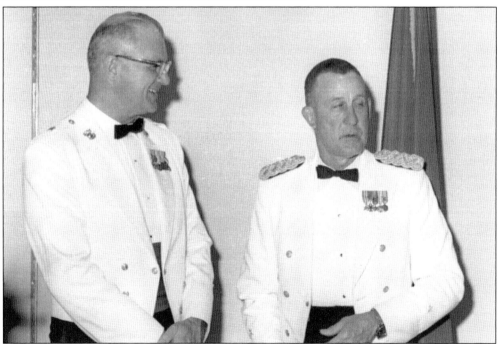

ADVICE OF EXPERIENCE. Retiring superintendent George Shell (1931), left, congratulates the new superintendent, Richard Irby (1939), at his inauguration in 1971. Lieutenant General Shell had guided VMI through an era of major construction at VMI and national social unrest. Richard Irby came to the Institute after a 32-year career in the U.S. Army during which he saw combat in World War II, Korea, and Vietnam.

WRITTEN COMMUNICATION, 1972. A letter from home can brighten the entire week, but too often a trip to the mailbox results in disappointment. Rats are not allowed to pick up their own mail. Their first class dyke, or big brother, provides this service for the new cadets. In return, the rat helps clean the first classman's room or rolls the first classman's hay (mattress) and puts up his hay rack (folds and places the cot against the wall).

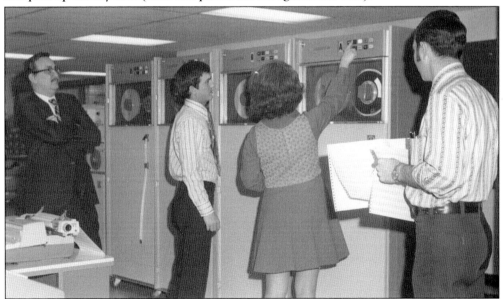

ARRIVAL OF THE COMPUTER AGE, 1973. The first main frame computer was installed at VMI in 1963, but it would be the Burroughs B 5500, seen here, that would allow academic computing to become a standard feature of cadet education. The system also provided administrative computer support. The installation of the Burroughs B 5500 ushered in the first effort to share state university computing technology and resources over telephone lines—the Internet was still a couple of decades into the future.

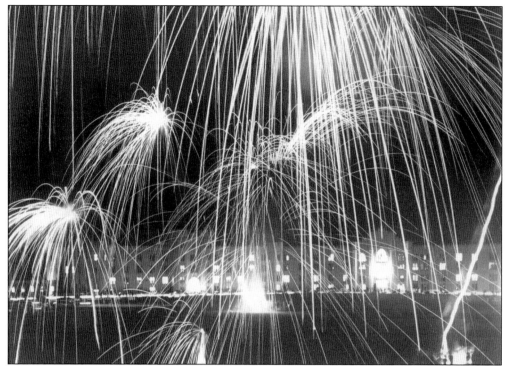

FINALS 1973. Since the first graduation exercise—originally held on the Fourth of July—many graduations included fireworks on the Parade Ground until the practice was discontinued in the early 1970s. Graduation has been held in mid-May since the 1970s. Since the early 1990s, the VMI Parade Ground has been the site of the community Fourth of July fireworks display.

UNIFORMS OF THE 1970S. With the exception of the fatigue uniform (far left), rain cape, and class uniform (seventh and eight from left respectively), the traditional uniforms of the Corps have changed little through the 20th century. Compare this assembly with cadet dress from an earlier era on page 29.

HISTORY-MAKING CATCH.
Ronnie Moore (1976) made
VMI sports history during the
1974 Southern Conference
Championship game against
East Carolina University. He
caught a Tony Farry (1975) pass
in the end zone after it had
been deflected twice by the
East Carolina Pirates. The catch
gave VMI its only touchdown
in the 13–3 title-deciding
win over ECU, the two-time
defending Southern Conference
champions. It was the first
conference championship
for the Institute since
1962. (VMIAA.)

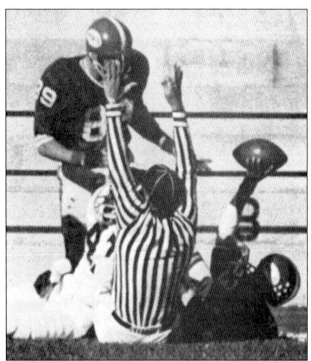

NAVY/MARINE ROTC UNIT COMMISSIONING, 1974. With the establishment of NROTC, VMI
became one of only five colleges in the nation to offer all ROTC branches. U.S. Army ROTC
was started at VMI in 1916, and U.S. Air Force ROTC was added in 1946 (three years before
it became a separate service branch). VMI requires that all cadets take four years of ROTC,
but they are not required to receive a commission upon graduation. Approximately one half
of the graduating class accepts a commission. (VMIAA.)

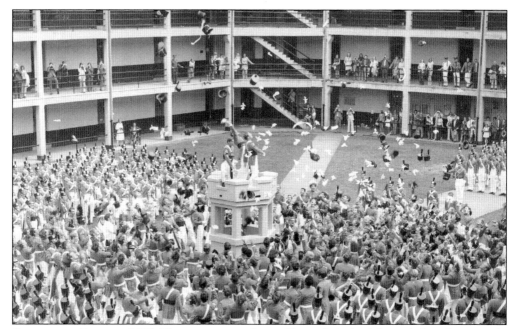

GRADUATION PARADE, 1974. The soon-to-graduate Class of 1974 celebrated their last parade in the traditional manner of gathering around the Sentinel Box, giving an "Old Yell" for their class, and tossing their shakos (dress hats) into the air. All VMI parades begin and end in the Barracks Courtyard.

HERBERT NASH DILLARD (1934). Colonel Dillard served the Institute as an inspired teacher for 38 years. A noted scholar of Romance poets and Shakespeare, Colonel Dillard inspired generations of cadets with his flamboyant style and mastery of his subject. His annual trips to New York City and Europe were highlights of many cadetships. Colonel Dillard died of a heart attack in his classroom while lecturing in his Saturday morning class on January 31, 1976.

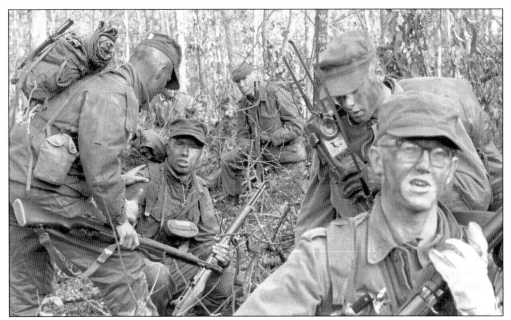

FTX. Twice during the academic year, cadets gain practical experience in their respective military branches during five days of Field Training Exercises (FTX). Until the mid-1970s, when this image was made, FTX usually meant spending a week in the nearby national forest. More recently, cadets pursuing commissions might visit military installations or ships to receive specialized training.

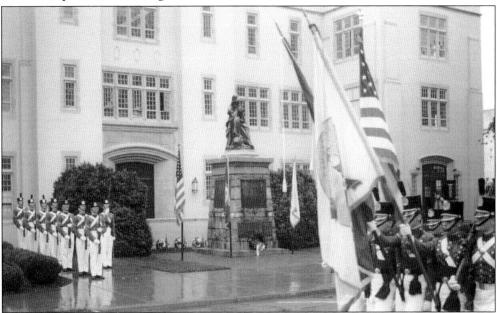

NEW MARKET DAY, 1975. Since May 15, 1866, the Corps of Cadets has recognized its participation in the 1864 Civil War Battle of New Market on the anniversary date. The solemn observance consists of a wreath-lying at the graves of six of the 10 cadets who died, the firing of a ceremonial volley, and the passing in review by the Corps. As the name of the 10 cadets who died is called, a cadet among the ranks responds, "Died on the field of honor, sir."

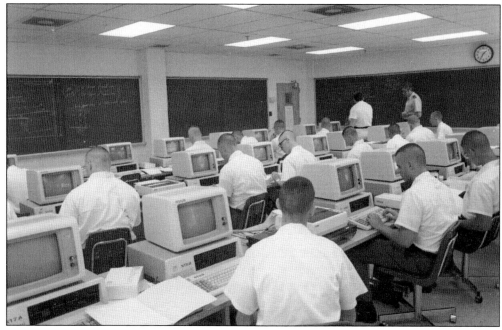

NOT SO PERSONAL COMPUTERS. By 1975, the first personal computer labs were installed. These IBM machines, unlike the user-friendly devices of today, required users to know computer programming languages such as Basic, Fortran, and Cobal. One syntax error could produce hours of frustration.

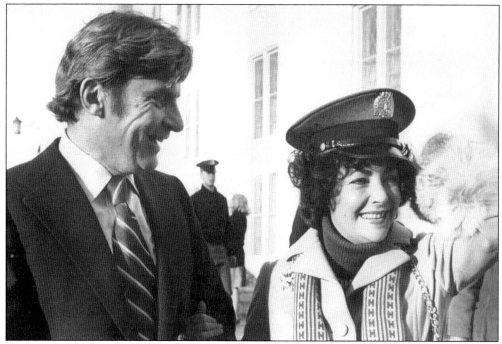

VERY BECOMING. Elizabeth Taylor tries on a cadet hat during her visit to VMI on Founders Day, November 11, 1976. She accompanied her husband, U.S. Sen. John Warner of Virginia, who delivered the Founders Day address.

Six

CONTINUING
THE MISSION

NEW CADET ARRIVING, 1976. With a strictly prescribed assortment of items and unlimited anticipation, a new cadet arrives at Limits Gates. Within an hour, the cadet proceeded through the matriculation process, said goodbye to his parents, and stepped into the Rat Line. When trains were the usual mode of arrival, parents often did not accompany their sons to matriculation. Since the 1980s, matriculation day has been redesigned to accommodate the families of the new cadet.

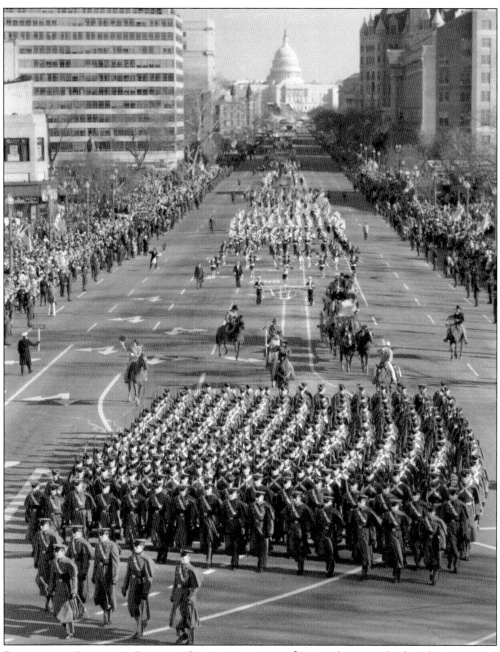

PRESIDENTIAL INAUGURAL PARADE, 1977. A contingent of 250 cadets marched in the Inaugural Parade of Pres. Jimmy Carter. The Corps departed Lexington before dawn on a very cold day and was back in Barracks by midnight. Between 1909 and 2009, the Corps marched in 13 presidential inaugural parades.

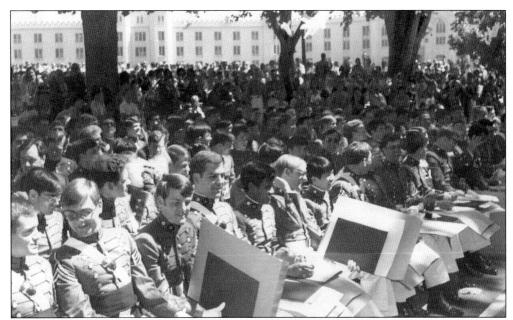

GRADUATION, 1977. Seated facing Preston Library, the Class of 1977 attended their last formation as cadets. On that occasion, Gov. Miles Godwin reminded the graduates of their responsibility to the legacy of service rendered by earlier alumni. Prior to World War II, commencement was held in Jackson Memorial Hall. After the war, it was held in Cocke Hall until the early 1960s, when the size of the event outgrew the facility. From that time until the construction of Cameron Hall in 1985, graduations were held outside in front of Preston Library.

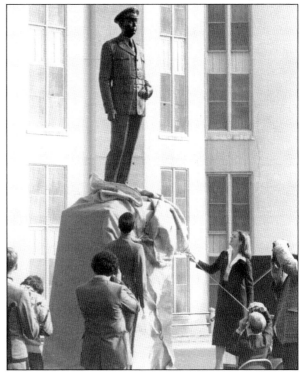

MARSHALL STATUE DEDICATED, 1978. Mrs. Michael Mobbs (right of statue), granddaughter of George Marshall (1901), unveiled the heroic bronze statue of her grandfather during the dedication on Founders Day, November 11, 1978. The concept for this statue dated back to the early 1950s, when the plans called for his likeness in front of the Barracks Arch named in his honor. It was not until Supt. Richard Irby reintroduced the idea in 1977 that the project was completed. The 7-foot bronze statue stands atop of an 8-foot-tall granite base and weighs a total of 18 tons. It is the work of sculptor Augusto Bozzano of Mexico.

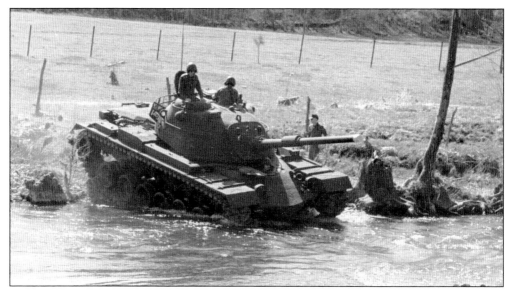

NO BRIDGE, NO PROBLEM! Capt. Jim Joyner (1967), U.S. Army ROTC instructor, is the tank commander seen here guiding his new M48A5 across the South River. In 1978, the VMI Military Department received five new M48A5 tanks to replace the older M48A1. The new tanks arrived by train in nearby Buena Vista and were driven cross-country to the Institute. From 1948 until the tank program was discontinued in the mid-1980s, VMI and West Point were the only colleges in the nation with their own tank platoons.

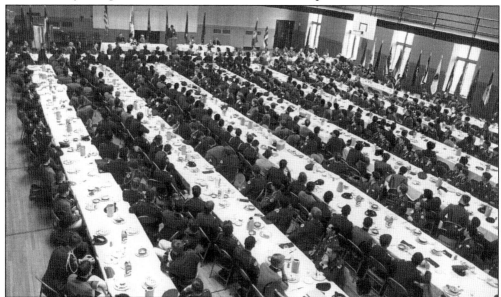

MARSHALL AWARDS CEREMONY, 1978. Josiah Bunting (1963) addressed the luncheon meeting of the first Marshal ROTC Awards Conference, which was held in 1978. The annual event is conducted by the George C. Marshall Foundation and the U.S. Department of the Army and honors the top-ranking Army ROTC cadet from each of the 270 ROTC units in the nation. The three-day program brings together high-ranking military and civilian leaders with the cadets in round table and workshop events. Bunting became the twelfth superintendent of VMI, serving from 1995–2002.

COLLECT CALL, AROUND 1979. The first telephone at VMI was installed in the mess hall in 1890. For many years, it was the only phone on post; barracks rooms were not equipped with telephones. Cadets wanting to place a call had to use one of the pay phones located in the "concourse," a passageway connecting old and new barracks. There were always more cadets than phones. Cadets who placed a call after taps risked receiving a penalty from the commandant's office. Since the advent of cell phones and Internet communication in the 1990s, things changed. All cadets, with the exception of rats, may have cell phones.

CONSTRUCTION OR DECONSTRUCTION? A construction survey team checks the accuracy of progress on Cameron Hall. The multi-purpose building, dedicated in 1981, was named in honor of benefactors Bruce Cameron (1938) and Dan Cameron (1942). The 5,000-seat arena is the home of VMI basketball and hosts internationally recognized lecturers, theatrical productions, concerts, and even performances by the famed Lipizzaner Stallions.

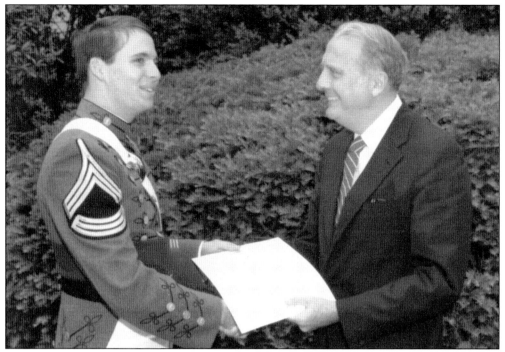

A Proud Father. Scot Marsh (1981) received his U.S. Army commission from his father, U.S. Secretary of the Army John O. Marsh Jr. At the time of Secretary Marsh's retirement in 1989, he was the longest serving U.S. Secretary of the Army. Marsh has also served VMI in many capacities. As a U.S. congressman, he was the dedicatory speaker at New Market Battlefield State Historical Park in 1967, and he served on the VMI Board of Visitors. Following his military service, Scot Marsh became an engineer and has been active in alumni affairs.

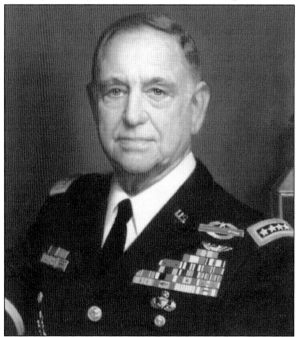

Sam Sims Walker (1945). In 1981, Gen. Sam Walker became the 11th superintendent following a distinguished U.S. Army career. Sam Walker's father, Walton Walker (1906), was also a four-star general. There have been only two four-star, father-son pairs in the history of the U.S. Army. Mandatory commissioning, which had been introduced in the 1970s, was discontinued during General Walker's administration.

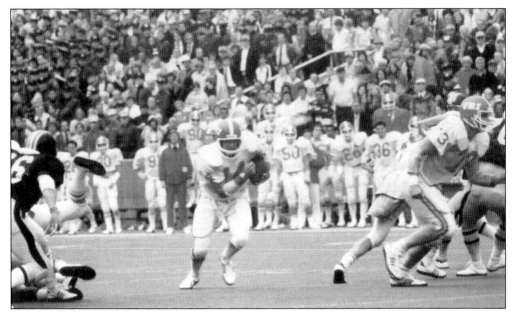

BEAT ARMY! Number 14, VMI quarterback Kelly Raber (1982), looks for yardage in the Institute's 14–7 upset win over West Point on September 19, 1981. The victory at West Point marked the only time in the 13 games the two military schools have played that VMI has won.

ONE SIZE NOT FITTING ALL. The "new cadet" ritual includes visits to the Institute tailor shop and military store where each cadet is fitted for uniforms, hats, shoes, and boots. The cadet grey uniforms are still made of 100 percent wool, but they are provided by a major uniform manufacturer and then tailored to the cadet. Good diet and physical training often results in cadets changing two or three uniform sizes during their four-year cadetship.

A BIG RING! Many years ago, while preparing for their Ring Figure Dance, some second classman realized the similarity of form between their notoriously large class rings and the 200-pound, Civil War–era naval cannonball, which sits at the northeast corner of the Parade Ground. Since then, every November witnesses the transformation of that cannonball into a 200-pound class ring. At other times during the year, it is cleverly altered into an Easter bunny, or a Thanksgiving turkey.

FIRST CLASS INSPECTION. During a formal inspection in the fall of 1982, five brother rat roommates stand at attention in the rear of their room while cadet officers inspect. Even today while inspection is conducted, all lockers and storage boxes must be open. Note in this photograph that the desk drawers are slightly open to reveal contents. Only rat (freshmen) rooms are inspected by first classmen (seniors). Officers of the Institute inspect upper-class rooms.

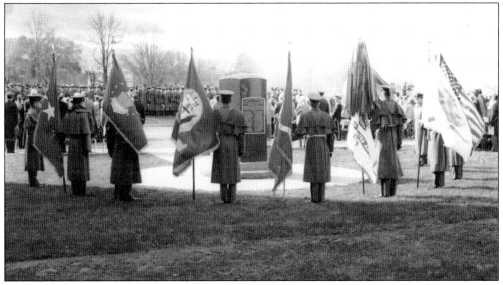

CITIZEN-SOLDIER MONUMENT DEDICATION, NOVEMBER 11, 1983. This granite octagon, which lists the names of all VMI Cincinnatus medal recipients, was dedicated on a blustery November 11, 1983. The day marked the 200th anniversary of the Society of Cincinnati and the 144th anniversary of the Institute. The monument, designed by sculptor Ceasar Rufo, was originally located at the end of New Barracks (1948). In 2006, the 9.5-ton monolith was moved to its current location in front of Preston Library to make room for the 2008 barracks expansion.

THE OLDEST TRADITION. From the moment the Institute was founded on November 11, 1839, serving on the Cadet Guard Team has been a part of cadet life. Between 1839 and 1864, the cadets were responsible for the security of the State Arsenal. During the academic year, each day a different cadet company is responsible for staffing the guard. First classmen fill the command positions of officer of the day, and officer of the guard; second classmen serve as sergeant of the guard. Third classmen are assigned as corporals of the guard, and fourth classmen serve as sentinels of several posts. Standing guard continues today as the Institute's oldest tradition.

MOBILE HOME, 1986. The construction of the new science building in 1986 required moving the historic Pendleton-Coles House several hundred feet. The Gothic Revival cottage, built in 1869 by post surgeon Robert Madison, was the home of Lilly Coles when cadet George Marshall (1901) came to court her. In 1902, the couple was married in the house. Today the cottage serves as the VMI admissions office. (VMIAA.)

SALUTING A FLAGPOLE. For many years, John Kitridge of El Paso, Texas, stopped by the Institute annually to put a fresh coat of silver paint on the two 75-foot-high flagpoles in front of the Barracks. What seemed like a death-defying stunt for most people was all in a day's work for Kitridge, who painted about 500 flagpoles a year. The poles were the gift of the Class of 1920 and were installed that year. Prior to 1920, the national and state flagpoles were mounted on top of the Washington Arch towers. Guard team sentinels were sent to the top of the towers twice a day to raise and lower the flags. In recent years, the local fire department ladder truck has been used to provide painting assistance.

THE KEYS TO THE ARSENAL. Joe Spivey (1957), president of the VMI Board of Visitors (left) presented Lt. Gen. John Knapp (1954) the key to the arsenal during Knapp's inaugural as the 12th superintendent. The symbolic gesture recalled the occasion of November 11, 1939, when Francis Smith, first superintendent, received the keys to the State Arsenal for the purpose of converting it into the Virginia Military Institute. Superintendent Knapp presided over the 150th anniversary celebration of the Institute.

DEDICATION OF THE NEW SCIENCE BUILDING, 1989. One of the highlights of the sesquicentennial celebration of the Institute on November 11, 1989, was the dedication of a new combined sciences classroom and laboratory facility. The modern version of Gothic Revival departed from the more traditional architectural interpretations found at VMI. In 2010, the building was named Maury-Brooke Hall in honor of Matthew F. Maury and John M. Brooke, distinguished scientists and members of the VMI faculty. (VMIAA.)

STONEWALL SANTA CLAUS! Dedicated in 1912, the heroic bronze statue of Stonewall Jackson is the work of VMI graduate Moses Ezekiel (1867). Jackson served as professor of natural philosophy and artillery tactics from 1851 to 1861. In July 1861, at the Battle of Manassas, Jackson earned the nickname for which he is remembered when a fellow officer shouted, "There stands Jackson like a stone wall!" At Christmas time, the statue has been known to take on a kinder image. (VMIAA.)

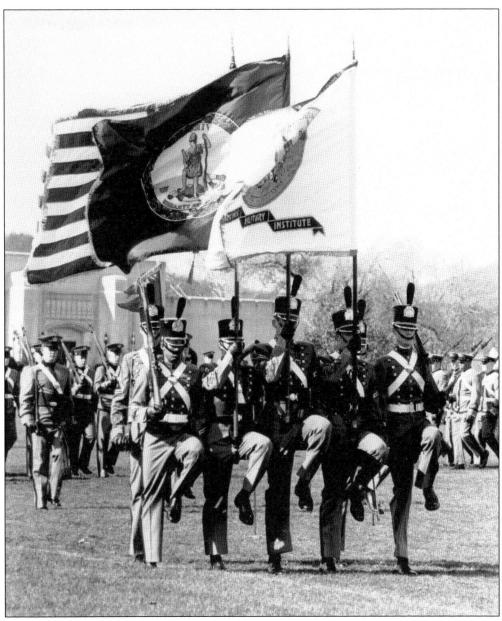

THE VMI COLOR GUARD, 1996. From 1842 until 1864, the Corps marched with only the VMI Regimental flag, a white silk flag, which featured a medallion of George Washington on one side and the seal of Virginia on the reverse side. This was the banner carried by the Corps at the 1864 Battle of New Market. In June 1864, the flag was destroyed by the cadets to prevent its capture by Federal forces. The Virginia flag was the only flag carried from 1865 until about 1890 when the national flag was added. Although the flag was reproduced in 1909, it was not until 1958 that the Corps flag (now known as the New Market flag) was added, thus creating the three-flag Color Guard seen today.

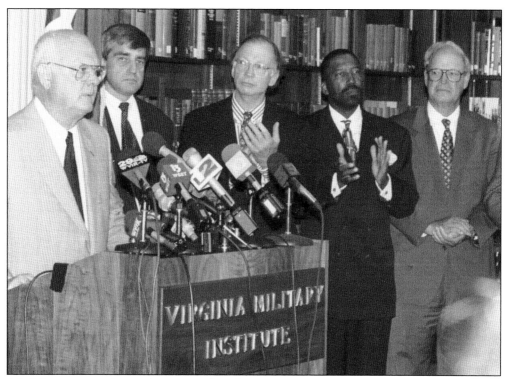

A 9-8 Decision. On September 21, 1996, William Berry, president of the VMI Board of Visitors, announced that VMI would remain a public college and that women would be admitted for the first time in the fall of 1997. Earlier that summer, the U.S. Supreme Court ruled that VMI must admit women or lose public funding. The 9-to-8 VMI board decision ended a six-year court battle. Women currently comprise approximately 8 percent of the 1,500 member Corps of Cadets.

The VMI Pipe Band. Drawing on the Scots-Irish heritage of the Shenandoah Valley, the VMI Regimental Band fielded bagpipers for the first time in January 1997. Over the past decade, the Pipe Band has become a popular component at VMI parades. Surprisingly, most pipers arrive at VMI with no previous training. The distinctive tartan they wear is the official, registered VMI plaid.

Seven

TRADITION, CHANGE, AND ANOTHER CENTURY

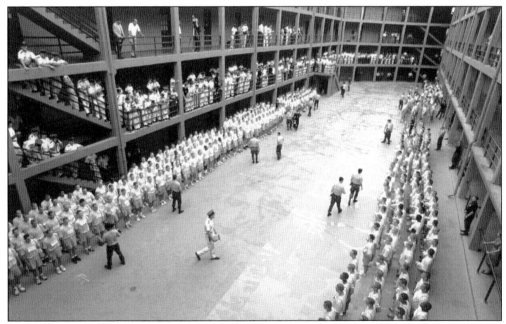

RATS MEETING THEIR CADRE! Once matriculation is completed and uniforms have been issued, the new cadets form up in the New Barracks courtyard to await the arrival of their cadre. The cadre is made up of specially selected and trained upperclassmen who will instruct the new cadets in the fundamentals of military drill and cadet life the week before the return of the "Old Corps." The ceremonial introduction of the cadre, complete with drums and drama, dates to the 1980s. It is a noisy affair designed to encourage new cadets to pay close attention to the instruction of the cadre.

THE GIFT OF ENGLISH GENTLEMEN. In the spring of 2001, Brig. Gen. Charles Brower IV, dean of faculty, presided over the dedication of the Jackson-Hope Award Monument. Listed on the monument are the recipients of the Jackson-Hope Medals, which have been presented annually since 1877 to the two graduating cadets with the highest grade point averages. This award was created with funds raised in tribute to the memory of Stonewall Jackson by a group of English admirers.

WOMEN GRADUATE, 2001. The 15 women who graduated in May 2001 were the first women who matriculated as rats in 1997. Here Supt. Josiah Bunting presents cadet Erin Claunch with an award during the ceremony. Cadet Claunch majored in physics and served as 2nd battalion commander during her first-class year.

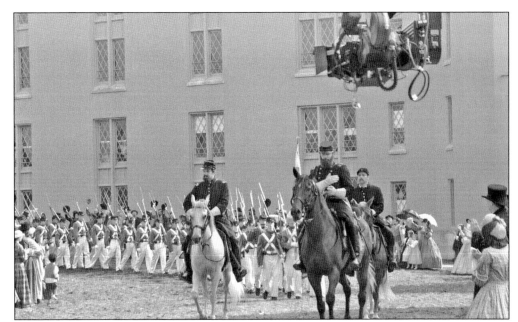

FILMING A MAJOR MOTION PICTURE, BETWEEN CLASSES. *Gods and Generals,* produced in 2003, centered on the Civil War career of VMI professor Thomas "Stonewall" Jackson (portrayed by actor Stephen Lang). Much of the movie was filmed on location at VMI in the fall of 2001. The day the scenes of Jackson leaving VMI were shot happened to have been the first day of classes for the new academic year. The film crew had to pause filming every 50 minutes while class bells rang and cadets passed through the set en route to their next class. (C&M.)

THE RETURN OF THE CADET BATTERY. Through the generosity of author Jeff Shaara, the VMI Cadet Battery was completely restored in 2001. Amid the cheering onlookers, the cannons were returned to their station near the statue of "Stonewall" Jackson on Founders Day, November 11, 2001, having been towed across the Parade Ground by the 2nd Virginia Cavalry reenactment unit. When the cannons resumed their place on the Parade Ground, the carriages were red (as research revealed they had been in 1848) instead of green, as they had been for decades. (C&M.)

MARINE ONE ON THE PARADE GROUND. On April 17, 2002, Pres. George W. Bush arrived at VMI aboard *Marine One* to address the VMI Corps and the Marshall ROTC Award recipients. Several VMI graduates have served as pilots with Marine Helicopter Squadron One, including Lt. Col. Daryl S. McClung Jr. (1965) for Ronald Reagan; Col. Timothy W. Fitzgerald (1983) for Bill Clinton; Lt. Col. Brent Hearn (1985) for Bill Clinton and George W. Bush; Lt. Col. Matthew C. Howard (1987) for George W. Bush; Capt. O. V. "Buck" Sessoms IV (1991), Lt. Col. Richard S. Barnes (1993), and Maj. Wade J. Dunford (1995) for Barack Obama. (C&M.)

Good Morning America! Diane Sawyer and Charlie Gibson broadcast live from Crozet Hall during breakfast on Founders Day, November 11, 2002. Lexington was a destination location for the ABC morning program. In addition to the live broadcast on a rainy fall morning, there were cadet interviews and glimpses into cadet life. (C&M.)

114

A Visit from the History Channel. VMI faculty and staff regularly appear on television and radio as subject-matter experts on many topics. One such memorable occasion was when the History Channel filmed an episode of *History vs. Hollywood* in 2003. The History Channel helicopter, seen here on the Parade Ground, was featured in several scenes. (C&M.)

Electronics Class, 2003. Cadet Jennifer Dineen, an electrical engineering major, observed a demonstration during an electronics class. Dineen graduated in 2005 and works as an engineer with Underwriters Laboratories. In the VMI tradition of service to community, she volunteers with the Elgin Literacy Connection teaching reading and writing to adults.

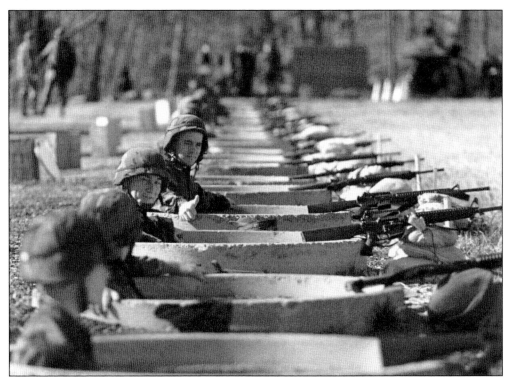

QUALIFYING WITH THE M16. Army ROTC cadets await their score results at the outdoor rifle range after firing the M16, the current U.S. Army shoulder arm. Since 1970, cadets have been issued M14 rifles for drill and parade purposes. The VMI Army ROTC detachment maintains several hundred M16s for instruction and qualification. (C&M.)

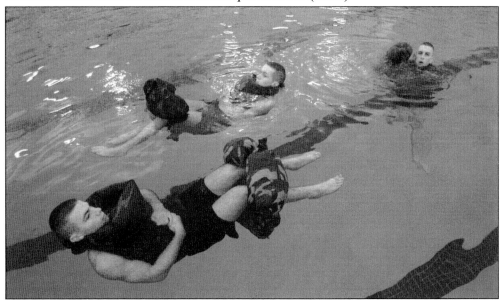

RAT SWIMMING CLASS, 2003. All cadets are required to pass a swimming and water survival class before graduation. As seen here, part of the final test requires cadets to create flotation devices out of their fatigue uniforms. (C&M.)

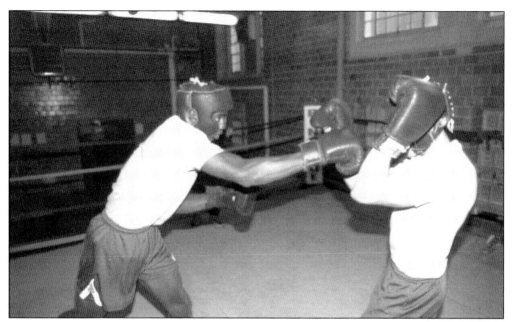

Boxing Class, Required. In addition to passing swimming and water life-saving classes, all cadets are required to pass boxing and wrestling. The requirement is designed to extend the new cadets beyond their comfort zone. The class helps young men and women realize that their physical and intellectual potential is far beyond what they otherwise might have imagined. (C&M.)

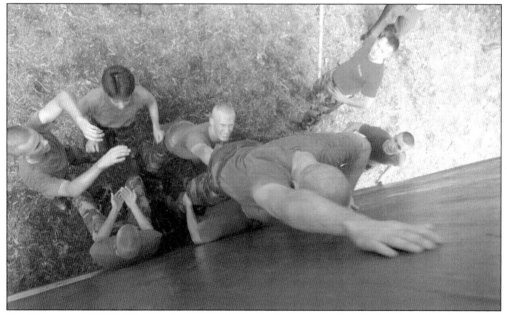

Rat Training, 2006. New cadets experience a rigorous and well-developed military and physical training program known as "Rat Challenge." Friendly competition between the rat companies encourages team building and class esprit. The current Rat Challenge Program was developed in the late 1980s, but variations of the program have existed for several decades. (C&M.)

117

Virginia Premiere of *Gods and Generals*, 2003. Col. Keith Gibson (1977), right, introduced key members of the cast and crew of *Gods and Generals* during the Virginia premiere held in Jackson Memorial Hall. From left to right are Brian Mallon (General Hancock), Stephen Lang ("Stonewall" Jackson), author Jeff Shaara, director Ron Maxwell, and associate producer Dennis Fry. Colonel Gibson served as a technical advisor on the film. The black-tie gala brought Hollywood to the over 900 attendees at the sold-out event. (C&M.)

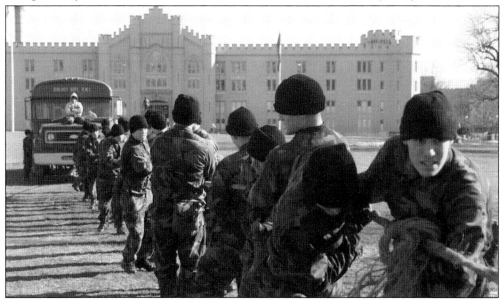

Role Reversal. In a demonstration of teamwork, the Class of 2006 pulled a bus (and its full tank of diesel fuel) across the Parade Ground as part of their Breakout activities. Breakout signifies the end of the Rat Line for the new cadets and comes approximately a month into the second semester. After breakout, the rats are considered full-fledged members of the Corps and then may refer to themselves by their class year, in lieu of the less-dignified term "Rat Class." (C&M.)

EARLY MORNING RUN. As part of their new cadet training, the fourth class goes on a pre-dawn run along the Blue Ridge Parkway. The famous and scenic road parallels the Appalachian Trail along the crest of the Blue Ridge Mountains and is within 10 miles of VMI. Such shared effort has long been a signature element of the rat year. The parkway offers breathtaking views of the Shenandoah Valley, once the sun rises! (C&M.)

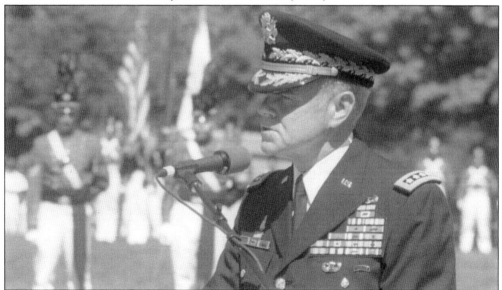

J. H. B. BINFORD PEAY III (1962). General Peay became the 14th superintendent of VMI in the summer of 2003. Here he is seen addressing the Cadet Corps for the first time that fall. Peay retired from the U.S. Army in 1997 following an illustrious career, which culminated with his duty as commander in chief, U.S. Central Command (CENTCOM). Throughout his VMI administration, Peay has provided vision and leadership through an ambitious era of growth, preparing VMI for the requirements of a 21st-century education. (C&M.)

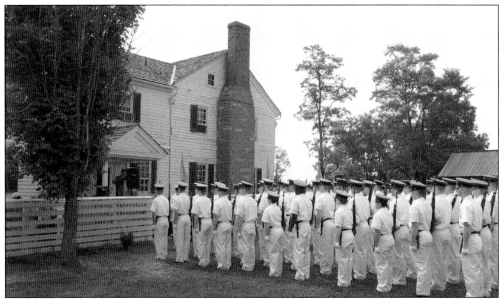

NEW CADETS TAKING THE OATH OF CADETSHIP, 2004. In the 1990s, Superintendent Bunting revived a tradition when he directed that the Cadet Oath be administered to the rats at the beginning of their cadetship. The oath occurs near the historic Bushong Farm during the fourth class visit to New Market Battlefield State Historical Park. The Cadet Oath is a declaration of the cadet's commitment to adhere to the standards expected of a cadet, to abide by the governing regulations, and to lead an honorable life. (C&M.)

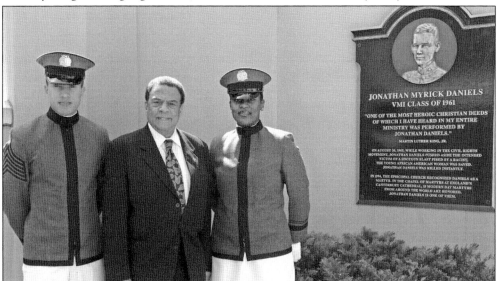

AMBASSADOR ANDREW YOUNG, DANIELS AWARD RECIPIENT. On March 23, 2006, Andrew Young, former U.S. ambassador to the United Nations, became the second recipient of the Daniels Humanitarian Award. The award recognizes an individual who has made a contribution of international scope to humanitarian efforts. Cadet Regimental Cmdr. Mark Searles, left, and Cadet Ketra Alexander, president of the Promaji Club, join Secretary Young at the Jonathan Daniels Courtyard at VMI. President Carter was the first recipient of the Daniels Award in 2001. (C&M.)

RING FIGURE, CLASS OF 2009. VMI was one of the first colleges in the nation that adopted the concept of a class ring. Each ring is designed by the class. The oldest example of the ring in the VMI Museum collection dates to the Class of 1848. Until about 1900, the rings were presented to class members during graduation. Since the 1920s, the ring presentation occurs during the fall of the second class year at the Ring Figure Dance, the highlight of the second-class year. (C&M.)

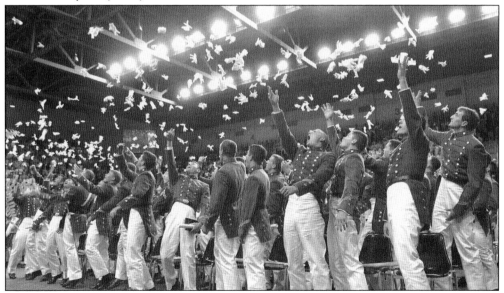

GRADUATION 2007. Since 1981, graduation has been held in the 5,000-seat Cameron Hall. The entire Corps attends, along with thousands of family members and friends. Each graduate walks across the stage to receive the diploma, with distinguished graduates preceding. After the order pronouncing the official release from duty is read, white gloves fill the air in celebration. (C&M.)

TWO-PERSON JOB. First class cadet officers demonstrate to their "dykes" (fourth classmen) the process of "dyking out" for parade. The process requires the assistance of a second person. The term "dyke" means assistant in the VMI vernacular. Compare this image with the one on page 42, which was taken 100 years earlier. (C&M.)

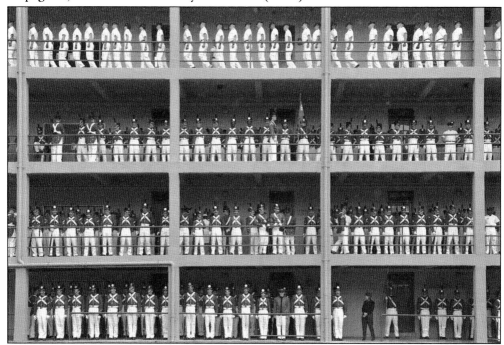

INSPECTION ON THE STOOP. A late summer shower required Formal Inspection to be held on the stoop of the Old Barracks. This photograph captures the first inspection of a new academic year—the "Old Corps" (first, second, and third classes) are standing inspection, while the new cadets (fourth classmen or "rats") are rushing off to another formation. Each of the four classes lives on a specific floor ("stoop")—the firsts on the ground stoop; seconds on the second stoop, thirds on the third stoop, and the rats on the very top stoop. First classmen have been heard to say, "At VMI you start at the top and work your way to the bottom." (C&M.)

BIGGEST UPSET IN THE HISTORY OF VMI SPORTS. Chavis Holmes drives for a basket during the VMI vs. University of Kentucky game, which was held at Rupp Stadium on November 13, 2008. VMI stunned the world of college basketball with a 110-103 win over the University of Kentucky. The game ranks as the biggest regular season upset win in VMI history. Chavis Holmes and his twin brother Travis are the third set of twins who played basketball at VMI. They became the NCAA's all-time leading scoring twins in 2009. (SID.)

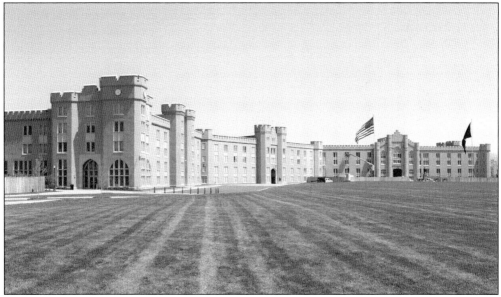

THIRD BARRACKS, 2008. Architect Alexander Jackson Davis had planned for the Barracks to expand incrementally as the size of the Corps grew. Since the first section opened in 1851, the Barracks has been added to no fewer than six times, most recently in 2008. Third Barracks, far left, is linked to its predecessors with interior sallyports on every level. One of the features of the new Third Barracks is the return of the Post Clock, which was originally over Washington Arch but was destroyed in the 1864 fire (see page 18). (VMIM.)

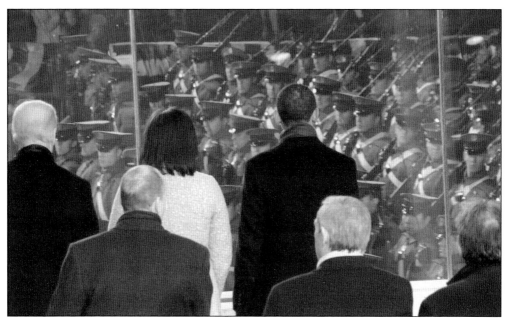

PRESIDENTIAL INAUGURAL PARADE, 2009. President and Mrs. Barack Obama watched as the entire 1,400-member VMI Corps passed in review during his inaugural parade in January 2009. The Corps first appeared in a presidential inaugural parade in 1909 (see page 45). Participation in the once-in-a-lifetime event is symbolic of the service VMI alumni citizen-soldiers provide to the nation. (DoD.)

KILBOURNE HALL, 2009. In 2009, VMI opened the largest ROTC college complex in the nation. Named in honor of Lt. Gen. Charles Kilbourne (1894), Medal of Honor recipient and sixth VMI superintendent, the complex houses the U.S. Army, Air Force, Navy, and Marine Corps units. A new main entrance building ties together the existing 1939 building, which was originally built as the VMI cavalry stables, left, and the 1968 Kilbourne Hall, right. (VMIM.)

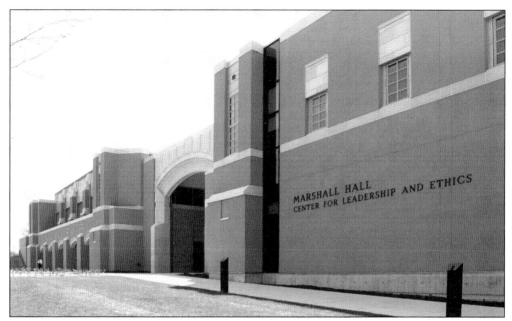

MARSHALL HALL, 2009. Also dedicated in 2009, the George C. Marshall Center for Leadership and Ethics provides a 500-seat lecture and performing arts theater as well as a conference facility. Named in honor of General of the Army George C. Marshall (1901), this new building is home to the VMI Theater and the Hall of Valor. Located on the southern edge of the post, the center is a popular venue for public and cadet-based programs. (VMIM.)

THE SUPERINTENDENT'S QUARTERS. Designed by Alexander Jackson Davis, the home was completed in 1862. When the rest of VMI was burned by Union forces in June 1864, the Superintendent's Quarters were spared. General Smith called on Gen. David Hunter, explained that his daughter had just come through a difficult birth, and that moving her might result in death. In a moment of empathy, Hunter decided to use the lower floor of the home as his headquarters during his two-day stay in Lexington. (VMIM.)

FIRST WOMAN TO WIN THE THREE-LEGGED STOOL. Cadet Audrey Falconi (2010) became the first woman to win the Three-Legged Stool Sports Award, which is given to a senior cadet-athlete that best exemplifies the three aspects of a VMI education: academics, athletics and military. There are seven women's NCAA sports teams. (SID.)

THE NATION'S LARGEST DISPLAY OF VALOR MEDALS. Pictured from left to right, Regimental Cmdr. Karster Bloomstrom, Regimental Capt. Elizabeth Dobbins and Cadet Capt. Barker Squire (all members of the Class of 2010) visit the Hall of Valor, Marshall Hall. The Hall of Valor started in the VMI Museum in 1968, but by 2007 the tribute had outgrown that space. In 2009, Marshall Hall became the new home for the unique exhibit. The extraordinary display features over 5,000 valor decorations awarded to more than 1,200 VMI alumni. The Hall of Valor is dedicated to Lt. Gen. Lewis B. "Chesty" Puller (1921), the most decorated Marine in U.S. history. (VMIM.)

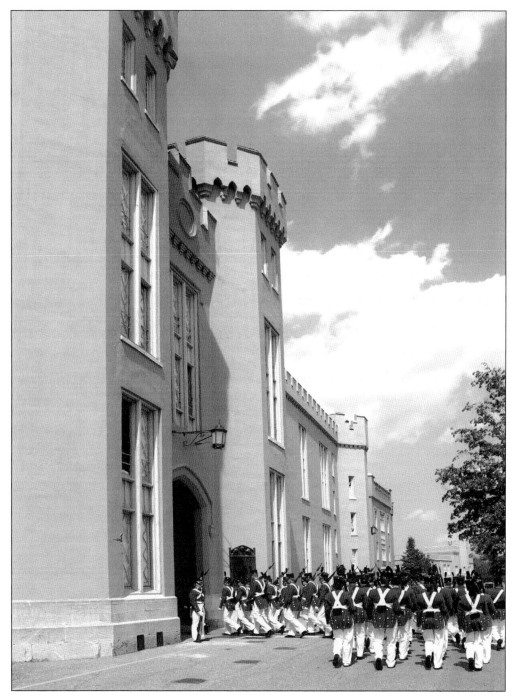

THE GRADUATION PARADE, 2010. In an event repeated through the centuries, the three underclasses return to Barracks after parading for, not with, the first class. The following day, 247 members of the Class of 2010 received their diplomas. Ready for the challenges that await them, half of the graduates accepted military commissions, while others continued to graduate schools or entered the business world. The graduation completes 170 years of John T. L. Preston's vision for his school. (VMIM.)

DISCOVER THOUSANDS OF LOCAL HISTORY BOOKS
FEATURING MILLIONS OF VINTAGE IMAGES

Arcadia Publishing, the leading local history publisher in the United States, is committed to making history accessible and meaningful through publishing books that celebrate and preserve the heritage of America's people and places.

Find more books like this at
www.arcadiapublishing.com

Search for your hometown history, your old stomping grounds, and even your favorite sports team.

Consistent with our mission to preserve history on a local level, this book was printed in South Carolina on American-made paper and manufactured entirely in the United States. Products carrying the accredited Forest Stewardship Council (FSC) label are printed on 100 percent FSC-certified paper.

MADE IN THE